10.00

KT-546-549

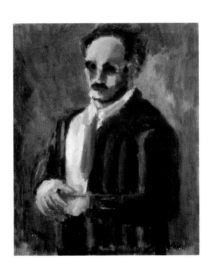

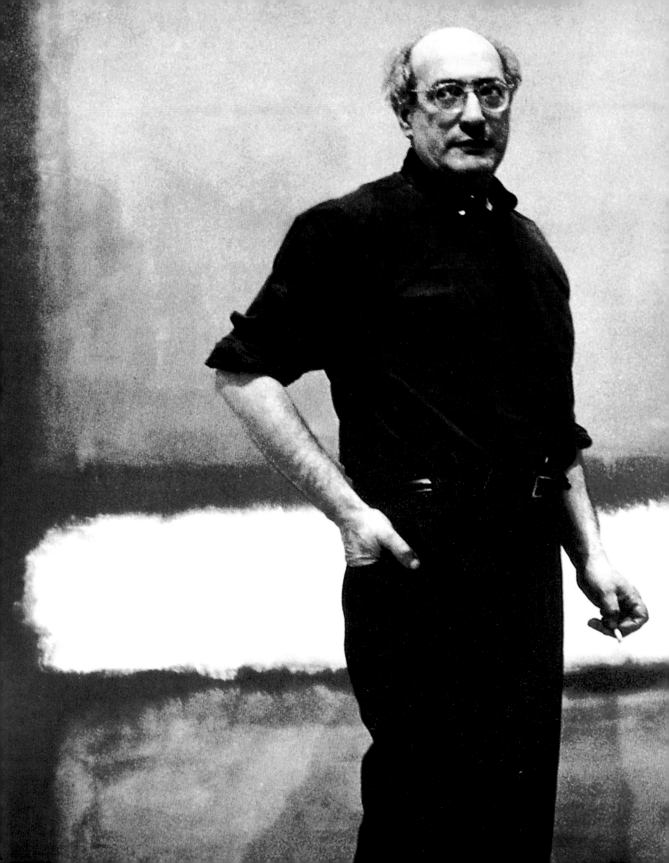

Jacob Baal-Teshuva

# MARK ROTHKO

## 1903–1970

## Pictures As Drama

**TASCHEN**

KÖLN  LONDON  LOS ANGELES  MADRID  PARIS  TOKYO

To stay informed about upcoming TASCHEN titles,
please request our magazine at www.taschen.com or write to
TASCHEN America, 6671 Sunset Boulevard, Suite 1508,
USA–Los Angeles, CA 90028, Fax: +1-323-463 4442.
We will be happy to send you a free copy of our magazine
which is filled with information about all of our books.

© 2003 TASCHEN GmbH
Hohenzollernring 53, D–50672 Köln
**www.taschen.com**

Editorial coordination: Gimlet & Partner, Cologne
Translation: Nicholas Levis, Berlin
Design: Catinka Keul, Cologne
Production: Ute Wachendorf, Cologne

Printed in Germany
ISBN 3–8228–1820–8

# Contents

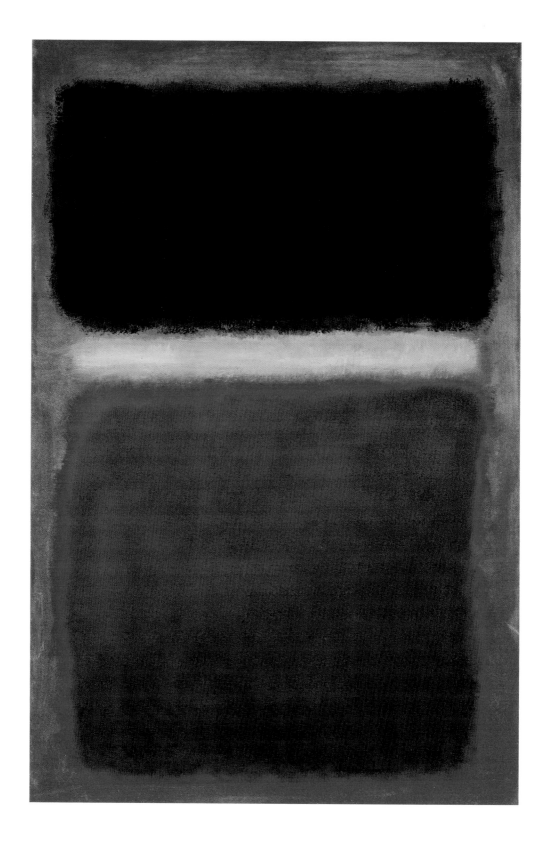

# Pictures As Drama

Mark Rothko (1903–1970) belongs to the generation of American artists who completely revolutionized the essence and design of abstract painting. His stylistic evolution, from a figurative visual repertoire to an abstract style rooted in the active relationship of the observer to the painting, embodied the radical vision of a renaissance in painting. Rothko characterized this relationship as "a consummated experience between picture and onlooker. Nothing should stand between my painting and the viewer." His color formations indeed draw the observer into a space filled with an inner light. Rothko always resisted attempts to interpret his paintings. He was mainly concerned with the viewer's experience, the merging of work and recipient beyond verbal comprehension. "No possible set of notes can explain our paintings," he once said. "Their explanation must come out of a consummated experience between picture and onlooker. The appreciation of art is a true marriage of minds. And in art as in marriage, lack of consummation is grounds for annulment."

Rothko was an intellectual, a thinker, a highly educated man. He loved music and literature and was involved in philosophy, especially in the works of Friedrich Nietzsche and of ancient Greek philosophy and mythology. His friends say he was a difficult, restless and irritable man. Despite a short temper, he was also known to be loving and affectionate. Rothko was a protagonist within the movement of American painters who became known as the Abstract Expressionists. First forming in New York City during the years between the world wars, this group was also called the New York School. In all the history of art, they became the first American artists to receive international recognition as a significant movement. Many among them, including Rothko, went down as the stuff of legend.

Modernist art since the late 19th century had been dominated by European currents, with its development centered mainly in the vibrant city of Paris. In the interwar and postwar decades, however, American painting gradually took over the leading role. The New York School achieved its full national and finally international breakthrough with a 1952 show at the Museum of Modern Art, known as "Fifteen Americans." In the late 1950s, Abstract Expressionist shows went on traveling tours of the major European museums and met with great interest. It was a triumphal time for a new movement that had finally achieved acceptance among critics and collectors around the world. Abstract Expressionism was thought to be new, fresh, and entirely unprecedented.

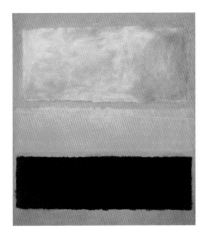

*No. 13 (White, Red on Yellow)*, 1958
Oil on canvas, 242.2 x 206.7 cm
New York, The Metropolitan Museum of Art,
Gift of The Mark Rothko Foundation, Inc., 1985

*Untitled*, 1956
Oil on canvas, 124.5 x 78.7 cm
Private collection, courtesy Knoedler Gallery,
New York

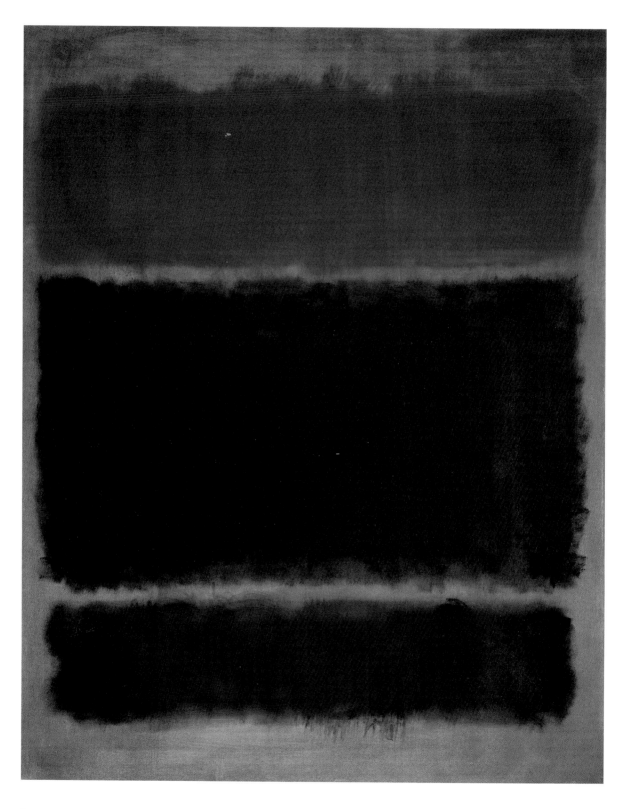

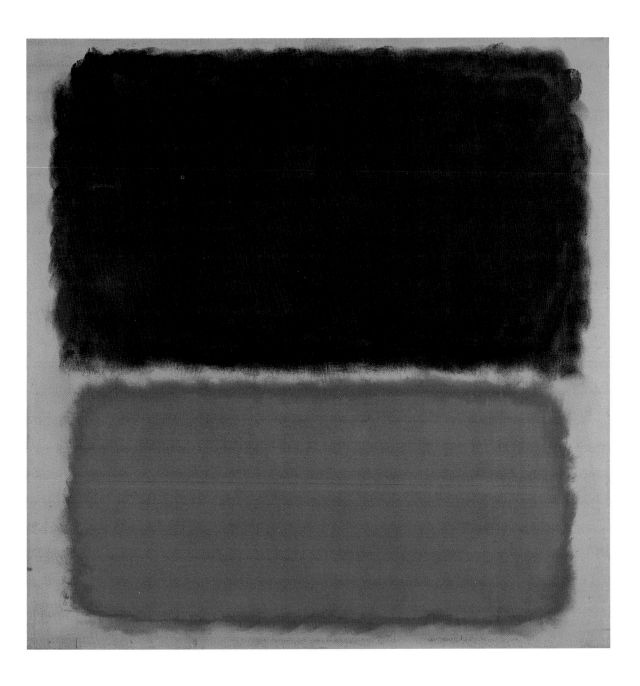

The term Abstract Expressionism refers more to a process than a style. The point is to express feeling through the act of painting itself, the process, without fixating on the actual product of that act, the artwork. Among the current's leading exponents were Jackson Pollock, Willem de Kooning, Adolph Gottlieb, Robert Motherwell, Franz Kline, Clyfford Still, Barnett Newman and Mark Rothko. By no means did the works of these artists display any form of visual unanimity. They were all influenced by European art, especially by Surrealism and Expressionism, and by artists such as Max Ernst, André Masson, Mondrian, Tanguy and Chagall, all of whom emigrated to the United States during the Nazi era. Another source of inspiration came from the stocks of the Museum of Modern Art in New York City, above all the late works of Monet, certain paintings by Matisse and Kandinsky, and the works of Manuel Orozco and other Mexican muralists.

The young painter William Seitz defined the Abstract Expressionist movement as follows: "They value expression over perfection, vitality over finish, fluctuation over repose, the unknown over the known, the veiled over the clear, the individual over society, and the inner over the outer." Abstract Expressionism was never a unified movement with a fixed program, however, but a loosely associated group of diverse artistic positions. American art critic Harold Rosenberg coined the term "action painting" to describe the works of Jackson Pollock, Willem De Kooning and Franz Kline. The subject of their works is the actual process or motion of painting. Rothko was definitely not an action painter. He, Barnett Newman and Clyfford Still are the leading exponents of the second major current in Abstract Expressionism, called "color field painting," in which the predominant element is not the gestural motion, but the emotional force of pure color.

Before the rise of Abstract Expressionism, the American art scene after World War I was defined in the main by two currents. A variety of what one might call Regionalists each used their own signature style in portraying the virtues of the hard-working rural American population. In the second group are the artists of Social Realism, whose work reflected American urban life during the years of the Great Depression. Neither of these two schools was interested in abstract art. They both upheld a rather conservative attitude to figurative representation. Even as these two styles dominated, many artists of the nascent New York School met frequently at the legendary Cedar Bar, where they discussed their radical theses. They argued endlessly about the problems of art, about how to effect a total break with the art of the past, about the mission of creating an abstract art that no longer had anything to do with conventional techniques and motifs. Their passionate conversations often wandered into the early morning hours. Most of this young and penniless abstractionist vanguard had no money, and lived within blocks of each other in Greenwich Village; but they were all passionate and enthusiastic. The circle of friends included one woman, Lee Krasner, who later married Jackson Pollock. Next to the influence of the French and other artists who fled the Nazis into exile, they were all affected by the great 1936 exhibition of Dada and Surrealism at the Museum of Modern Art. Another key factor was the 1942 opening of Peggy Guggenheim's famous Art of This Century gallery, where Pollock had his first one-man show. Among the influential and famous art dealers who promoted the new abstract art were also Betty Parsons, Sidney Janis and Leo Castelli.

Mark Rothko's 45-year painting career can be divided into four periods: the Realist years from 1924 to 1940, the Surrealist years 1940–1946, the Transitional

"We are reasserting man's natural desire for the exalted, for a concern with our relationship to the absolute emotions. We do not need the obsolete props of an outmoded and antiquated legend. We are creating images whose reality is self-evident and which are devoid of the props and crutches that evoke associations with outmoded images, both sublime and beautiful. We are freeing ourselves of the impediments of memory, association, nostalgia, legend, myth, or what have you, that have been the devices of Western European painting. Instead of making cathedrals out of Christ, man, or 'life,' we are making it out of ourselves, out of our own feelings. The image we produce is the self-evident one of revelation, real and concrete, that can be understood by anyone who will look at it without the nostalgic glasses of history."
BARNETT NEWMAN, 1948

*Untitled (Violet, Black, Orange, Yellow on White and Red)*, 1949
Oil on canvas, 207 x 167.6 cm
New York, The Solomon R. Guggenheim Museum, gift of Elaine and Werner Dannheisser and the Dannheisser Foundation

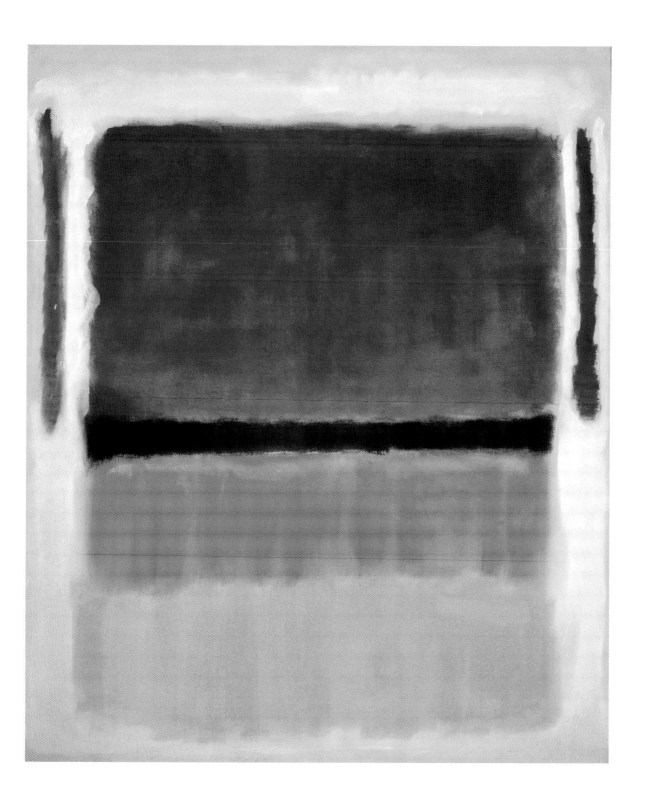

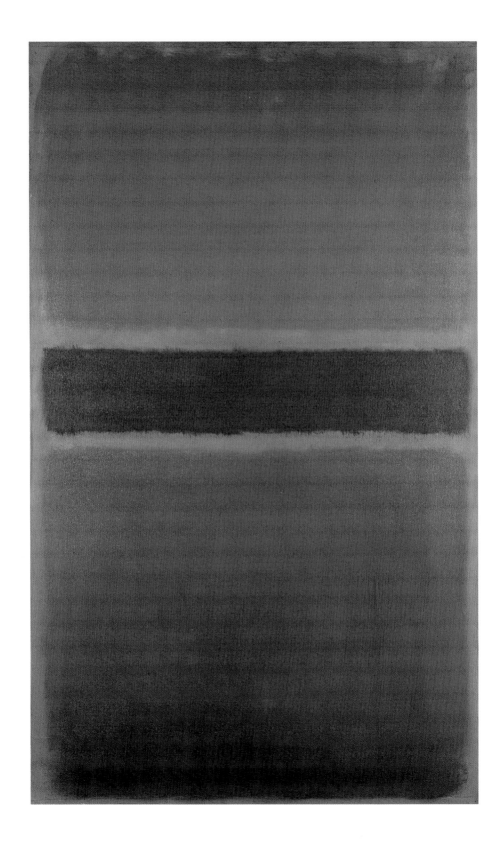

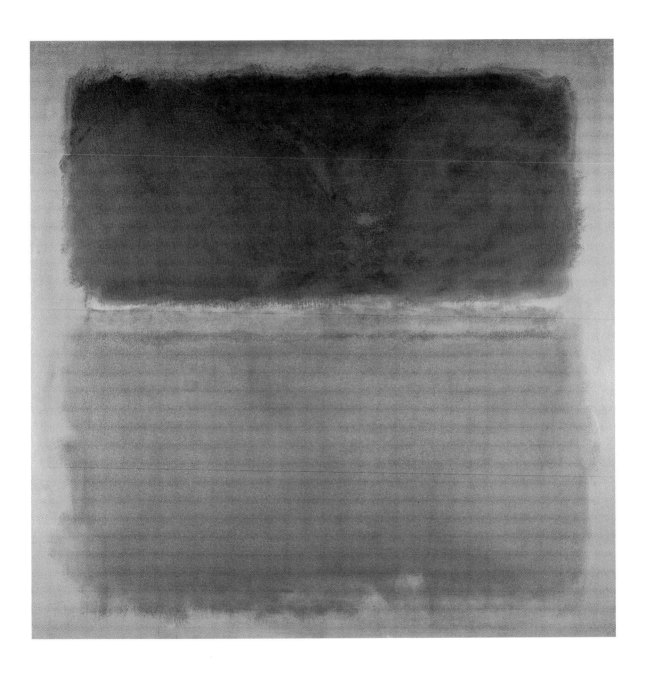

LEFT:
***Violet Stripe***, 1956
Oil on canvas, 152.3 x 90.8 cm
Destroyed

ABOVE:
***Blue Cloud***, 1956
Oil on canvas, 137.7 x 134.7 cm
Seoul, Ho-Am Art Museum

13

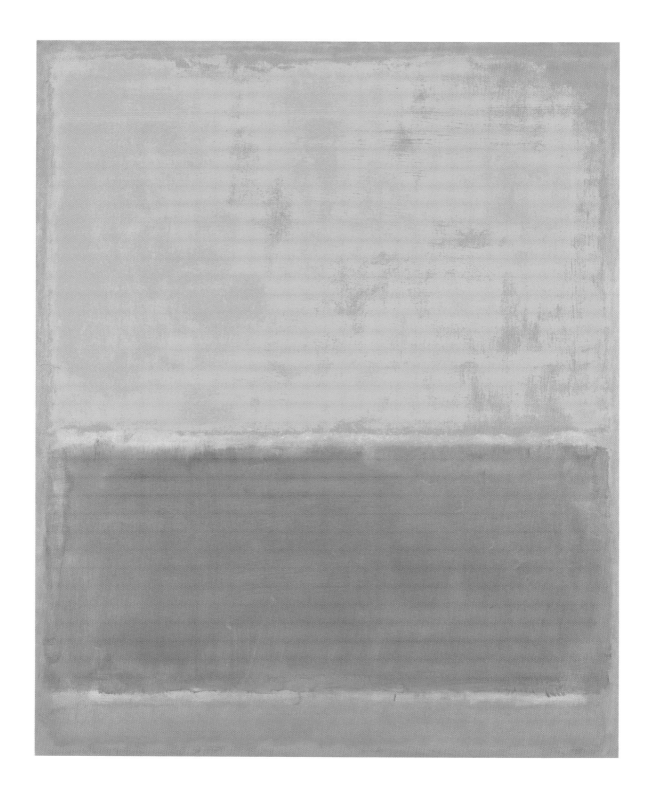

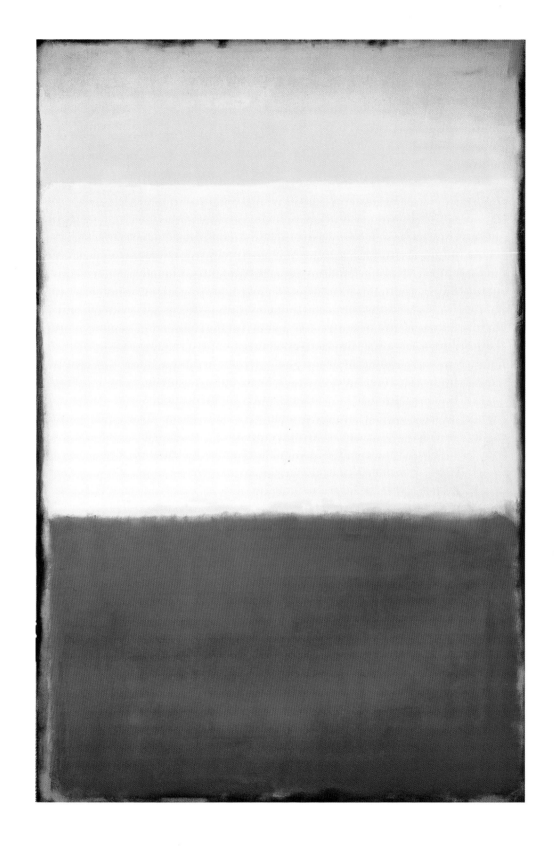

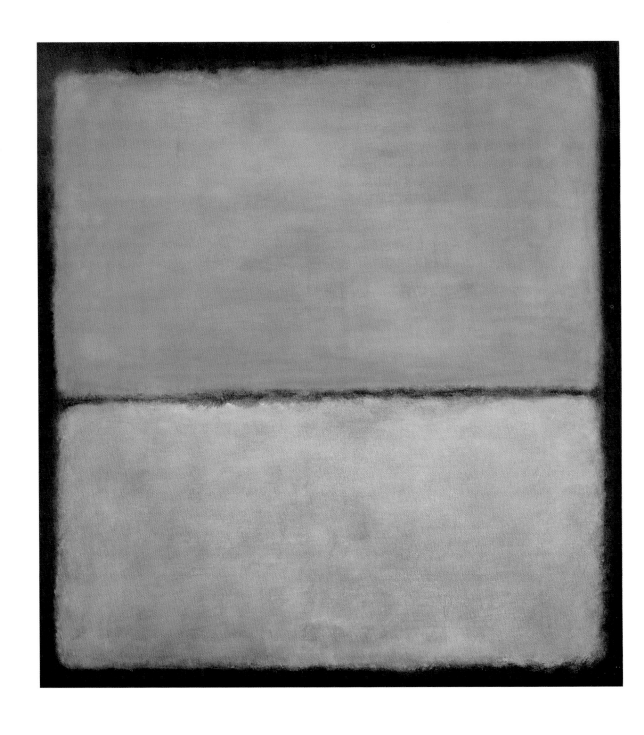

*No. 9 [?]*, 1956
Oil on canvas, 162.5 x 147.5 cm
New York, Robert Miller Gallery

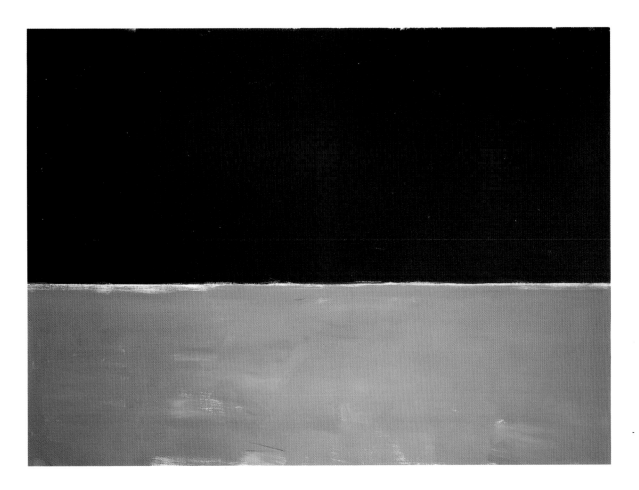

years from 1946 to 1949, and the Classical years from 1949 to 1970. During the first two stages, Rothko painted the landscapes, interiors, city scenes, still-lifes and the New York subway paintings that were so influential on his later development. His work during World War II and the immediate postwar period is marked by symbolic paintings, based in Greek mythology and religious motifs. During his period of transition to pure abstract painting, he created the so-called multiforms, which would finally evolve into his famous works of the classical period with their rectangular, hazy fields of color.

To Rothko, the trademark "mature" paintings, the ones that became synonymous with his name, went beyond pure abstraction. Rothko, for whom "tragic experience is the only source book for art," tried to make his paintings into experiences of tragedy and ecstasy, as the basic conditions of existence. The aim of his life's work was to express the essence of the universal human drama.

*Untitled (Black on Gray)*, 1969/70
Acrylic on canvas, 175.3 x 235 cm
Collection Kate Rothko-Prizel

PAGE 14:
*The Green Stripe*, 1955
Oil on canvas, 170.2 x 137.2 cm
Houston, The Menil Collection

PAGE 15:
*No. 6 (Yellow, White, Blue over Yellow on Gray)*, 1954
Oil on canvas, 240 x 152 cm
Collection Gisela and Dennis Alter

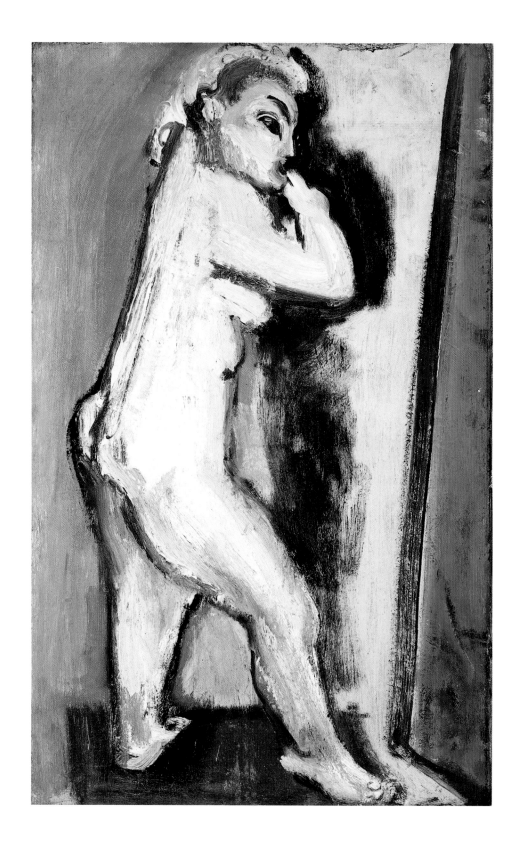

# From Russia To New York Via Portland, Oregon

Marcus Rothkovich was born on September 26, 1903, in Dvinsk, Russia, as the youngest of four children. His parents, Jacob Rothkovich (born in 1859) and Anna Goldin Rothkovich (born in 1870), married in 1896. Marcus's siblings were much older, his sister Sonia surpassing him by 14 years, his brothers Moise by eleven and Albert by eight years. Dvinsk is today part of Lithuania, and in 1990 was renamed Daugavpils (meaning "Fort on the Dauga"). The name recalls the birth of the town as a medieval fortress on the banks of the Dauga River, located in the Polish-Lithuanian kingdom until its annexation in 1722 by Russia under Czar Ivan IV.

Dvinsk numbered 90,000 residents at the time of Rothko's birth, half of them Jewish. Since Jews were barred from owning land, they tended to be merchants. Rothko's father was a pharmacist. The busy city was located at a railway junction and was thus easily reached by train from both St. Petersburg and Riga. The railways brought industrialization and mobility and promoted trade. As a highly developed industrial city, Dvinsk in 1912 was home to more than 100 factories with 6,000 employees, although the wages at the large railway and textile plants were rather meager. Rothko's father had a modest but steady income as a pharmacist. As a Russian-Jewish intellectual, he preferred secular education for his children and political over religious involvement. But the politically active and liberal Jacob Rothkovich turned to Orthodox Judaism after the brutal Russian pogrom against the Jews, which followed on the heels of the failed Russian Revolution of 1905. Jacob Rothkovich's return to the fold at the town synagogue came soon after Marcus's birth. Though they lived in constant fear, the Jews of Dvinsk were spared the pogroms and horrors visited upon the Jews of Kishinev, Bialystok and many other towns in Czarist Russia. Dvinsk witnessed only occasional outbreaks, even as thousands of Jews were killed elsewhere, branded as suspected sympathizers of the Social Democratic and other revolutionary parties.

Rothko was just two years old in 1905. His hometown was under the blanket surveillance of the Czarist secret police. Jews were the usual victims of reprisals whenever the Cossacks, the loyal followers of the Czarist state, came into the town to break revolutionary uprisings. Other Jewish communities in the environs of Dvinsk also lived in constant terror of pogroms and massacres. The air was filled with slogans like "Kill the Jews to Save Russia." This was the atmosphere in which Rothko grew up. Later, he claimed to recall dug-up pits in the

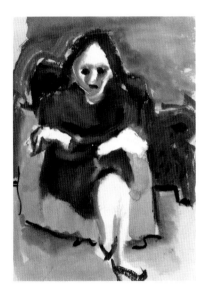

*Untitled*, c. 1930
Tempera on colored construction paper,
28.9 x 17.8 cm
The Mark Rothko Foundation, Inc.

*Untitled (Standing Female Nude)*, 1935/36
Oil on canvas, 71.1 x 43.2 cm
Collection Kate Rothko-Prizel

19

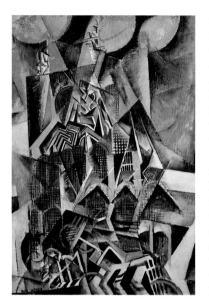

Max Weber
**Grand Central Station**, 1915
Oil on canvas, 152.5 x 101.6 cm
Madrid, Museo Thyssen-Bornemisza

forests around Dvinsk, where the Cossacks buried Jewish victims they had kidnapped and murdered. These images always plagued him mentally, and he says they exercised a certain influence on his painting. Some art critics have gone so far as to say this explains his preference for rectangular forms in the late works, as a formal echo of the grave, but we may rightly doubt that. Rothko could not have possibly witnessed any mass executions, and there were no mass graves in Dvinsk at this time. Far more likely is that the child heard adults talking about the pogroms and massacres elsewhere, and in his memory ended up mixing up these stories with his own memories of the nearby woods.

As an educated family and active Zionists, the Rothkoviches spoke Hebrew in addition to Russian and Yiddish, according to Mark's older brother Moise, later Maurice. Whereas the older siblings attended public schools along with many other Jewish children, father Rothkovich decided that his son Marcus would receive a strict religious education. He was sent to the cheder, the religious school run by the synagogue, starting at the age of five, where he was subject to a strict and tiring set of ceremonies: reading the text of religious laws, praying, translation of Hebrew texts, learning the Talmud by heart. As a result, Rothko was pushed into the role of an outsider, in contrast to his much older siblings. Later he complained that he had not had very much of a childhood.

When Marcus reached the age of seven, his father, like many other Jews in Dvinsk, decided to emigrate to the United States. The father's idealism and generosity were causing losses for the pharmacy. He also feared that his sons would be drafted into the Czarist army. Two of Jacob Rothkovich's brothers had moved to Portland, Oregon, many years before, where they had started very successful clothing firms. Jacob's plan was to go to the United States alone and have his family follow him once he had established himself. He left Russia, went through Ellis Island, and from there moved straight to Portland. At the time, the town on the confluence of the Willamette and Columbia rivers was a booming center of the logging industry, with more than 200,000 residents. One year after the father's arrival in Oregon, he was followed by Marcus's two older brothers, Albert and Moise, who thus managed to avoid the Czarist draft. Markus remained in Dvinsk with his mother and his older sister Sonia. They were constantly subject to the economic insecurities and political dangers of the Jewish pale. Only in 1913, when Marcus was ten years old, did the rest of the family finally move to America.

They departed from the harbor of Liebau on the Baltic, on board the steamship SS Czar. They arrived in New York in mid-August, after a 12-day journey in second class. They stopped to stay with acquaintances in New Haven for ten days, then boarded a train for the trip across the continental United States to the West Coast and Portland. During the two-week journey, they wore small signs around their necks to announce that they spoke no English. Their arrival was joyously celebrated by the Portland relatives, who had built a wooden house for the Rothkos, but their hope of a life in freedom and security soon disintegrated. Marcus's father Jacob, who worked at his brother's clothing store, died just seven months after their arrival, on March 27, 1914. His death left the family forced to find another way to make a living. One of Marcus's older brothers changed his name to Roth and worked at unskilled odd jobs, while his sister Sonia, a trained dentist, ended up working a cash register. Although he was still very young, Marcus worked after school at his uncle's warehouse. He also sold newspapers, for just a few cents a day. The family managed to hold themselves above water. Sonia later found a job as a dental assistant and Moise opened a pharmacy, where

*Untitled (Seated Woman)*, 1938
Oil on canvas, 81.6 x 61.6 cm
Collection Christopher Rothko

Albert also worked for a time before opening up his own drug store. Rothko's mother Kate was then able to take boarders.

Marcus was placed in the first grade of an American elementary school in September 1913, where he and other immigrant children were expected to learn the language by listening. He was skipped to the third grade in the fall of the next year, and was placed in the fifth grade that spring. In the shortest time he learned English and made friends in the neighborhood. Marcus completed the last four classes, through ninth grade, in just three additional years. After another three-and-a-half years, in June 1921, at the age of 17, Marcus graduated with excellent grades from Lincoln High School.

There were many Jewish immigrants in Portland, and they were concentrated in one neighborhood. At their community center, they spoke Yiddish or Russian. After the family had achieved a degree of economic security, they began to join local chapters of radical movements. The sensitive and rather nervous Marcus was similarly inclined, and increasingly participated in discussions on current affairs. He argued quite skillfully for the right of workers to strike, or for general

*Street Scene*, c. 1937
Oil on canvas, 73.5 x 101.4 cm
Washington, DC, National Gallery of Art,
gift of The Mark Rothko Foundation, Inc., 1986

access to contraception. His entire family was in favor of the Russian Revolution, as Rothko later said. But he was not a social rebel. His youthful anarchism seems to have been more a romantic pose than a political ideology. While at Lincoln High School, he took art classes without yet having decided on an artistic career. He was very interested in music, an enthusiasm that lasted for many years. He learned to play the mandolin and piano by ear.

Thanks to his good grades Marcus received a scholarship to Yale, as did his two friends Aaron Director and Max Naimark. At the elite university in Connecticut, the three young Jews soon discovered the difficulties of gaining social acceptance. At the time, Yale still upheld a limit on the number of Jews accepted. The majority of generally affluent White Anglo-Saxon Protestants were contemptuous of the Jewish minority. Marcus chose a major in the humanities and rented the attic of a doctor's house. He started an underground student newspaper called *The Yale Saturday Evening Post*, which took aim at the college's teaching methods and fetish for prestige. Though his grades were good his scholarship ran out after one year, and he was forced to take jobs as a waiter and gopher for laundry to finance his studies. He dropped out of Yale after his second year, but 46 years later he did receive an honorary doctorate from the Fine Arts department.

In the fall of 1923, Marcus decided to go to New York, where he rented a room on the Upper West Side. He took all manner of jobs in the Midtown garment district and as an accountant to pay the rent. Now he was 20 years old and lived on his own. According to his own stories, he discovered painting by coincidence, when he visited a friend at the famous Art Students League and saw that the students were making sketches of a naked model. "I knew then that this would be my life," he said. Eight months after dropping out of school, in January 1924, he enrolled in the Art Students League himself and took courses in anatomy with George Bridgeman, and in drawing. Two months later, he returned to Portland to visit his family. There he joined a theater group directed by Josephine Dillon, Clark Gable's first wife. His ambitions as an actor proved to be a short interlude, though he later loved to claim that he was a better actor than the Hollywood star Gable. But Rothko's plump form and average height of 5'10" made him look awkward on stage.

Restless as he was, he soon went back to New York and enrolled in the New School of Design, a small commercial graphics institute, where he was taught by Arshile Gorky. He took further courses at the Art Students League in October 1925 and took lessons in drawing from nature. Soon thereafter, Rothko decided to enroll in the class of Max Weber, the famous American painter who taught a course in still-life. Weber and Rothko had something important in common, having both come to the United States as Russian-Jewish immigrants at the age of ten. Weber, one of the most celebrated pioneers of Modernism in America, had traveled to Paris in 1905, at the age of 24. There he met the famous Fauves (Savages), a group of painters around Henri Matisse, André Derain and Maurice de Vlaminck, and came under the influence of Paul Cézanne and Matisse, studying for a short time under the latter.

After returning to the United States in 1908, Weber devised his own form of expressionist painting, attempting to translate his inner spiritual vision into a fabric of forms and colors. His lessons constantly emphasized the emotional power of art and the divine spirit he believed inhabited an artwork. Art to him was not just representation but revelation, even prophecy. This romantic idealism made a lasting impression on Mark Rothko. His works from the late 1920s,

Arshile Gorky
*The Betrothal*, 1947
Oil on canvas, 127.5 x 100 cm
New Haven, CT, Yale University Art Gallery,
Katherine Ordway Collection

Milton Avery
**Sitters by the Sea**, 1933
Oil on canvas, 71.1 x 91.4 cm
Private collection

Milton Avery
**Gaspé-Pink Sky**, 1940
Oil on canvas, 81.3 x 118.8 cm
Collection Mr and
Mrs Samuel H. Lindenbaum

"One of the things I like is how painterly his work is, and how he was almost painting in a new way. His approach in the late work hasn't been followed up on very much, but I think those works are particularly important … He was one of the last painterly painters, really into the act of painting. In a way he's very historically isolated because of this quality … With Rothko there is a belief that touch and paint are about emotion, whereas for the others paint is simply about paint … His touch affects the whole feel of the painting … I like his mobility, that he wasn't attached to a situation. He could do all these beautiful small paintings on paper, as well as these grand, huge ones. I see him in the tradition of grand painting, artists who dealt with large ideas and communicate a lot … What's in my mind is Delacroix and Courbet."
Brice Marden, 1997

mostly interior and urban scenes in a pastose, dark, expressionist style, clearly betray the influence of Weber.

In New York, Marcus Rothkovich took a growing interest in museums and gallery exhibitions. He saw the works of Georges Rouault, whom his teacher greatly admired, and those of the German Expressionists, as well as Paul Klee. He filled his sketchbooks with landscapes, interiors, still-lifes and other scenes. In 1928, at the age of 25, he showed his works for the first time in a group exhibition at the Opportunity Gallery, a small city-subsidized venue that promoted the works of young artists. Marcus also gathered experience in advertising, and was hired to draw maps and illustrations for the *Graphic Bible* by Lewis Browne, a retired rabbi from Portland who had become a best-selling author. When Rothko saw he was not credited as the creator of these works, he sued Browne for 20,000 dollars in damages. In the end, he lost the trial.

Starting in 1929, Rothko gave lessons twice a week in painting and clay sculpting at the Center Academy, a school that belonged to a Jewish education center in Brooklyn. Rothko himself initiated art lessons at the school and continued teaching there until 1952, for more than 20 years. In a speech delivered in the mid-1930s at the school, he talked about the relationship "between the painter who paints well and the artist whose works breathe life and imagination." He also spoke of "the difference between sheer skill and skill that is linked to spirit, expressiveness and personality… the result is a constant creative activity in which the child creates an entire child-like cosmology, which expresses the infinitely varied and exciting world of a child's fancies and experience." Rothko believed that one's means of artistic expression is unrelated to manual ability or painterly technique, that it is drawn from an inborn feeling for form; the ideal lies in the spontaneity, simplicity and directness of children.

Through his friend the violinist Louis Kaufman, Marcus in 1932 became acquainted with painter Milton Avery, 18 years his senior. The encounter with Avery, known in the United States as "the American Matisse," was of great significance. Avery's devotion to his craft and balanced and calm nature impressed the insecure and ever-searching Marcus. Milton and his wife, Sally, woke up each morning at six and worked until six in the evening. "Avery was the least importunate and least exaggerated person that anyone could imagine," said Louis Kaufman. Rothko never forgot the important hours he spent in Avery's studio. "Countless pictures always hung on the walls, always new ones, pictures full of poetry and light," he described the studio in retrospect. His visits to Avery became more frequent and the influence on his work was evident. In the early 1930s, Rothko created a series of aquarelles with beach scenes, in which the sandy areas take up the most space (ill. p. 25). Sea and sky are indicated by green and gray stripes. The figures on the beach are surrounded by areas of paper left white, and therefore seem to float above the sand. Avery's continuing influence is obvious even in Rothko's mature works, with their simplified forms, expressive application and thin layering of color (ill. p. 24).

At some point around the year 1929, Rothko became friends with an artist his own age, Adolph Gottlieb, who belonged to the clique around Avery together with Barnett Newman, John Graham and Joseph Solman. Gottlieb and Rothko first met at the small Art Center Gallery and the Opportunity Gallery as a result of the first group exhibition. The friendship between Rothko, Gottlieb and Milton Avery became increasingly tight. They spent several summers together at Lake George and in Gloucester, Massachusetts, where they painted during the day and spent the evenings in discussion. In New York, Rothko and Gottlieb

visited the Averys on an almost daily basis. The Averys gave a weekly course in nude drawing and held literary readings at their apartment.

In the summer of 1932, on a visit to Lake George, Marcus met Edith Sachar, a young, attractive jewelry designer whom he married on November 12 of the same year. The relationship began as a romantic affair with mutual artistic ambitions. After their return they ran into financial problems due to their bohemian lifestyle in New York, but their affection remained strong as ever.

Rothko had his first one-man show at the Portland Museum, in the summer of 1933. Next to his own works, he also showed pictures by children from his classes at the Center Academy in Brooklyn. On display were his latest aquarelles and drawings, inspired by Cézanne and John Martin. Truth be told, however, the Rothkovich family, who experienced serious money problems during the Depression, could not comprehend why their Marcus had chosen to be an artist. They accused him of failing to support his mother and never writing to her.

A few months after his summer in Portland, Rothko had his first big New York exhibition, at the Contemporary Arts Gallery. For the first time he showed oil paintings, 15 in all, mostly portraits, in addition to aquarelles and drawings.

*Bathers or Beach Scene (Untitled)*, 1933/34
Watercolor on paper, 53.3 x 68.6 cm
Collection Christopher Rothko

Especially singled out for praise by the critics were Rothko's aquarelle landscapes, with their seemingly casual style and predilection for large fields of color. At the time, Rothko's aquarelle technique was definitely ahead of his skills as an oil painter, but his love of large colored surfaces was already apparent. He frequently painted female nudes. His women are corpulent, rendered in thick, heavy, moving lines, without superfluous detail. His pictures from this period are defined by expressionist distortions with undertones of melodrama.

Rothko constantly spoke out for artistic freedom, albeit without becoming directly active himself. One case where he did becme involved, however, was the famed 1934 incident between the all-powerful John D. Rockefeller and the socialist painter, Diego Rivera. This began when Rivera was hired to paint a gargantuan mural in the lobby of the main building of Rockefeller Center, the newly completed showcase of the oil baron's ideals. Shortly before Rivera completed his work, Rockefeller dropped in and saw that the mural had a defiantly anti-capitalist message and was centered on a heroic depiction of Vladimir Ilyich Lenin. He ordered the removal of the mural, resulting in its destruction. After this incident, a group of 200 New York artists gathered to protest against Rockefeller, and Mark Rothko marched with them.

He was also a founding member of the Artists Union. In late 1935, artists started Gallery Secession, devoted to the newest artistic tendencies, and an avant-garde group called The Ten, which numbered no more than nine permanent members (so that the tenth place could vary). Among The Ten were Ben-Zion, Adolph Gottlieb, Louis Harris, Yankel Kufeld, Louis Schanker, Joseph Solman, Nahum Chazbazov, Ilya Bolotovsky and Marcus Rothkovich. They held meetings once a month, rotating among members' studios. The Ten refused to link themselves to any gallery, but planned instead to create a municipal art gallery that would allow self-organized group exhibitions. They succeeded, and took part in the 1936 opening of the Municipal Art Gallery. Painter Adolph Gottlieb described the group as follows: "We were outcasts, roughly expressionist painters. We were not acceptable to most dealers and collectors. We banded together for the purpose of mutual support." According to Gottlieb, "The whole problem seems to be how to get out of these traps – Picasso and Surrealism – and how to stay clear of American provincialism, regionalism and social realism." For all the differences among the members, who included Expressionists alongside exponents of geometric abstraction, The Ten acted as an alliance against the exaggerated promotion of regionalist art by the influential Whitney Museum of American Art, which to them was simply too provincial for words. Rothko said, "There was never any question in plastic art, in poetry, in music of representing anything. It is a matter of making something beautiful, moving or dramatic – this is by no means the same thing."

The Ten scored a major breakthrough in 1936, when they were invited to Paris to hold an exhibition in the Galerie Bonaparte. A French reviewer wrote that Marcus's paintings "display an authentic coloristic value." They followed up with a 1938 exhibition in the Mercury Gallery entitled, "The Ten: Whitney Dissenters." This show of protest, for which Rothkovich and Bernard Braddon wrote the catalog text, attracted a great deal of attention. By the time the group dissolved in 1939, The Ten had held eight group exhibitions in just four years, even displaying twice at the conservative Montross Gallery in New York.

During his time as a member of The Ten, from 1936 to 1939, Rothko also worked as part of the Treasury Relief Art Project (TRAP), a program of the Works Progress Administration, the labor relief agency founded by the federal govern-

*Untitled (Subway)*, c. 1937
Oil on canvas, 51.1 x 76.2 cm
Washington, DC, National Gallery of Art,
gift of The Mark Rothko Foundation, Inc.

ment in response to the Great Depression. Following the world economic crisis, TRAP employed artists in the renovation of public buildings. Rothko labored at this project for 15 hours a week, in the Easel Paintings department, for wages of 95$ and 44 cents a month. Other painters who worked for TRAP included Milton Avery, William Baziotes, James Brooks, Willem De Kooning, Arshile Gorky, Philip Guston, Lee Krasner, Louise Nevelson, Jackson Pollock, Ad Reinhardt, David Smith and no less than eight members of The Ten.

Around 1936, Marcus began to write on the development of creativity and the relationship between children's art and modern art. He planned a book, a theoretical analysis of painting. But all that remains of this effort is a sketch book with drafts for his speech on the occasion of the Center Academy's tenth anniversary, in 1938. In this "Scribble Book," he wrote about his many years of experience in teaching art to children:

"Often child art transforms itself into primitivism, which is only the child producing a mimicry of himself." He also wrote, "The scale conception involves the relationship of objects to their surroundings and the emphasis of things or space. It definitely involves space emotions. A child may limit space arbitrarily and thus heroify his objects. Or he makes infinite space, dwarfing the importance of objects, causing them to merge and become a part of the space world. There may be a perfectly balanced relationship."

Rothko was convinced that sustained creative activity can arise only when a child is encouraged from a young age to give concrete expression to ideas, fantasies and whims, without being limited by academic rules. Rothko believed that "the fact that one usually begins with drawing is already academic. We start with

Barnett Newman
**Who's Afraid of Red, Yellow and Blue I**, 1966
Oil on canvas, 190 x 122 cm
New York, private collection

color." He agreed with the famous Viennese art educator, Cizek, who said that children, like primitive artists, have an inborn feel for form, which should be encouraged to develop freely and without interference from the intellect. A few years later, this approach to the art of children would contribute substantially to Rothko's own liberation.

Of immense importance to his subsequent development were two 1936 exhibitions at the Museum of Modern Art in New York, "Cubism and Abstract Art" and "Fantastic Art, Dada and Surrealism." For the first time, young American painters saw the best works of their European contemporaries, without needing to go to Europe. Among the works at the second show were those of Giorgio de Chirico, whose art had a strong impact on Marcus's. Rothko painted a series of New York city scenes from 1936 to 1938 that seem to foretell the motifs and compositions of his mature period. These interiors, subway and street scenes place expressionist schematic figures in various narrow spaces, in a fashion recalling the Pittura Metafisica.

At the big retrospective of more than 100 Rothko paintings held in 1998 at the National Gallery in Washington DC, curator Jeffrey Weiss wanted to show that Rothko's painterly perspective is thoroughly urban, evocative of downtown space and big city light. This vision was already evident in Rothko's early paintings of the New York City subway, with their geometric and architectural elements pointing the way to greater abstraction. In his essay, Jeffrey Weiss wrote that "His affinity lies less with the open vision of landscape than with urban perspective, which is an alternately channeled and obstructed space."

Using walls, doors and other architectural elements as color fields, space is created through a simplified style compressed to an almost planar picture surface that only occasionally opens on a deeper perspective. Usually isolated or in couples, his figures occupy cleanly delimited spaces, so that they seem to be locked up, imprisoned. If Rothko's urban settings are usually vague, the subway clearly interests him for its unmistakable experience. The subway paintings (ill. p. 27) aim to encompass the whole loneliness and isolation of modern urban life.

The true themes of the subway paintings are his own story, the story of an immigrant outsider; his melancholy, his tendency to depression, how he deals with his own fate. In the ghost-like paintings, the subway becomes a place of alienation, of homelessness in the sense defined by Baudelaire. The underground space becomes a metaphoric space of the "underworld," a theme continued in his surrealist and mysterious visual architectures of the mid-1940s.

In the spring of 1946 the Mortimer Brandt gallery staged a comprehensive exhibition of Rothko's aquarelles, which had first been shown at the Portland Museum in 1933. A reviewer wrote that the works "incorporated Rothko's lyrical, mythical and metaphorical themes."

**Untitled**, 1946
Watercolor on paper, 98.4 x 64.8 cm
Collection of Ambassador and
Mrs. Donald Blinken

# Marcus Rothkovich Becomes Mark Rothko: Mythology And Surrealism

Marcus and his wife Edith separated temporarily in the summer of 1937. Their precarious financial situation led to frequent arguments. Edith opened a silver jewelry store and sold her pieces at crafts fairs. This helped them escape the financial difficulties that had put such stress on their marriage. Marcus nevertheless believed Edith was too materialist in her attitudes. They reconciled that fall, but the tensions remained.

Rothko became a United States citizen on February 21, 1938. This was 14 years after initiating an application for citizenship in 1924. Lackadaisical in its pursuit, he only finally formalized the petition in 1935. Like many Jews, he was worried about the rise of the Nazis in Germany and the possibility of a revival of anti-Semitism in America, and U.S. citizenship came to signify security. This was a time when many American Jews were modifying their names to sound less Jewish. In January 1940, Marcus Rothkovich decided to become Mark Rothko. More than 20 years earlier, Rothko's brothers had changed their names to Roth. But "Rothko" had the advantage that it did not sound American, Russian, Jewish, or like anything else in particular, and was therefore a bit uncanny, demanding of respect. The name change was only legalized in 1959, however, when he first acquired a passport.

Rothko left the American Artists' Congress in April 1940, along with Milton Avery, Ilya Bolotovsky, Gottlieb, Harris and several others. They all deplored the Russian invasion of Finland in 1939 and the Hitler-Stalin Pact, events that caused a break between the radical and liberal congress members and, finally, the dissolution of the body. The liberals, among them Rothko and his friends, joined with others that June to found the Federation of Modern Painters and Sculptors, which was devoted to "fighting for the welfare of free and progressive artists in America." Although the war was already upturning the whole world and political questions dominated original discussions, the group was more concerned with the fight for artistic independence and free expression, which were seen as equivalent to freedom and democracy. Art was to be kept free of nationalist, political, economic or historical issues. In 1941 the federation held annual exhibitions, in which Rothko took part.

During the worst years of the war, Rothko underwent a radical shift in his style, although the exact timepoint is unclear. The new works arose during his close partnership with Adolph Gottlieb, with whom he had endless discussions

*Composition*, 1941/42
Oil on canvas, 73.7 x 63.5 cm
Private collection, courtesy Jason McCoy, Inc.

"A picture lives by companionship, expanding and quickening in the eyes of the sensitive observer. It dies by the same token. It is therefore a risky and unfeeling act to send it out into the world. How often it must be permanently impaired by the eyes of the vulgar and the cruelty of the impotent who would extend the affliction universally!"
MARK ROTHKO, 1947

*The Omen*, 1943
Oil and graphite on canvas, 48.9 x 33 cm
Washington, DC, National Gallery of Art, gift of The Mark Rothko Foundation, Inc.

*Antigone*, 1939/40
Oil and charcoal on canvas, 86.4 x 116.2 cm
Washington, DC, National Gallery of Art,
gift of The Mark Rothko Foundation, Inc.

on the crisis of what subject to adopt for art. Both artists were convinced that American painting had reached a dead end, and they wondered about the ways that Rothko might go beyond his subway scenes with their Pittura Metafisica overtones. Barnett Newman often took part in these discussions and later described the dilemma as follows: "We felt the moral crisis of a world that was a battlefield, a world that was being laid to waste by the massive destruction of a raging world war... It was impossible to just keep painting like before – flowers, reclining nudes, or musicians playing the cello."

According to Gottlieb, he and Rothko in 1941–42 began a series of pictures inspired by mythological themes, especially from Greek myths. They sought out archaisms to which the war lent metaphoric potency. In "The Portrait and the Modern Artist," Rothko wrote: "Those who believe that the world today is less brutal and ungrateful than in these myths, with their overwhelming primeval passions, are either unaware of reality or they do not want to see it in art." The choice of mythological themes at the same time was an attempt to take on universal questions. Gottlieb and Rothko were interested in Freud's interpretations of dreams and C.G. Jung's theories of the collective unconscious, in addition to having read the ancient Greek philosophers. Rothko was fascinated by Plato and by Aeschylus's *Oresteia,* which he adapted into several episodes.

Rothko's archetypes depicted barbarism and civilization, dominant passions, pain, aggression and violence as primeval, timeless and tragic phenomena, without needing to take a position on the war as a historic event, playing instead with

*Untitled*, 1944
Watercolor and crayon with pencil traces on paper, 36.8 x 53.4 cm
Collection Mr and Mrs Michael Wilsey

***Astral Image***, 1946
Oil on canvas, 112 x 86 cm
Houston, The Menil Collection,
Bequest of Jermayne MacAgy

***Untitled***, 1944/45
Watercolor, ink on paper,
68.1 x 50.5 cm
Washington, DC, National Gallery of Art,
Gift of The Mark Rothko Foundation, Inc.

history on the metaphoric level. The multi-layered significance is evident in two of Rothko's statements on *The Omen of the Eagle* (1942). "The theme here is derived from the Agamemnon Trilogy of Aeschylus. The picture deals not with the particular anecdote, but rather with the spirit of myth, which is generic to all myths of all times. It involves a pantheism in which man, bird, beast and tree, the known as well as the knowable, merge into a single tragic idea."

The eagle was and is a national symbol for both Germany and America. Americans saw the war as a conflict between barbarism and civilization. Rothko united that savagery and civilization into a single barbaric figure that embodied aggression and vulnerability in one, the figure of the eagle. Asked again about the work in 1943, Rothko spoke simply of "the human tendency to slaughter each other, something that we know all about today." Rothko's biographer, James Breslin, said that he wanted to depict what "he liked to call the 'spirit of the myth,' not the Greek or the Christian subject matter, but the emotional roots, the essence of the myth that is effective across cultures."

Several of Rothko's mythical paintings were first presented at a 1942 group show at Macy's, the largest department store in New York City. Rothko's works there included *Antigone* (1939–40, p. 32) and *Oedipus* (1940), both of which had been shown earlier at the Riverside Museum in the first annual exhibition of the Federation of Modern Painters and Sculptors. (The third annual exhibition by the Federation would also include *Syrian Bull* and Gottlieb's *Rape of Persephone,* both from 1943.) Even before the show at Macy's opened in June, the *New York Times* published a negative review by Edward Alden Jewell, who waxed ironic on how the works by Rothko and Gottlieb completely befuddled him. In a June 6 follow-up, Jewell added that one of the artists had offered to help him with his "cluelessness." This provoked Rothko and Gottlieb to fire off a polemic letter to the *Times*, in which they championed Modernist art. Jewell published their rejoinder ("The Realm of Art: A New Platform and 'Globalism' Pops Into View") on June 13, interspersing it with his own ironic and unrepentant gloss. The artists' text was "as obscure as the paintings themselves," Jewell wrote. Rothko and Gottlieb were similarly smug in dealing with what they took as Jewell's ignorance: "To the artist, the workings of the critical mind is one of life's mysteries. That is why, we suppose, the artist's complaint that he is misunderstood, especially by the critic, has become a noisy commonplace.

"It is therefore an event when the worm turns, and the critic of the *Times* quietly yet publicly confesses his 'befuddlement,' that he is 'nonplussed' before our pictures at the Federation show. We salute this honest, we might say cordial reaction towards our 'obscure' paintings. For in other critical quarters, we seem to have created a bedlam of hysteria and we appreciate the gracious opportunity that is being offered us to present our views. We do not intend to defend our pictures. They make their own defense." In their fierce rebuttal, Mark Rothko and Adolph Gottlieb remained stubborn. Rothko would write several theoretical works through 1950, but he always refused to interpret or betray anything about his art or technique.

The artists at least indicated their intentions when they spoke, in the pages of the *New York Times*, of the "essence of the myth" : "We refuse to defend them, not because we cannot. It is an easy matter to explain to the befuddled that *The Rape of Persephone* is a poetic expression of the essence of the myth; the presentation of the concept of seed and its earth with all its brutal implications; the impact of elemental truth. Would you have us present this abstract concept, with all its complicated feelings, by means of a boy and a girl lightly tripping?

"It is as easy to explain *The Syrian Bull* as a new interpretation of an archaic image, involving unprecedented distortions. Since art is timeless, the significant rendition of a symbol, no matter how archaic, has as full a validity today as the archaic symbol had then. Or is the one 3,000 years old truer?"

Two points in this manifesto proved central to Rothko's later work. The first related to the relationship between the work and the observer; the second to the idea of a picture as a planned idea that transports prophetic or ethical messages. Both artists felt that interpretations would conceal the more significant vision behind the banal content:

"The point at issue, it seems to us, is not an 'explanation' of the paintings, but whether the intrinsic ideas carried within the frames of these pictures have significance. We feel that our pictures demonstrate our aesthetic belief, some of which we therefore list:

1. To us art is an adventure into an unknown world, which can be explored only by those willing to take the risk.

2. This world of the imagination is fancy-free and violently opposed to common sense.

3. It is our function as artists to make the specter see the world our way – not his way.

4. We favor the simple expression of the complex thought. We are for the large shape because it has the impact of the unequivocal. We wish to reassert the picture plane. We are for flat forms because they destroy illusion and reveal truth.

5. It is a widely accepted notion among painters that it does not matter what one paints as long as it is well painted. This is the essence of academicism. There is no such thing as good painting about nothing. We assert that the subject is crucial and only that subject-matter is valid which is tragic and timeless. That is why we profess spiritual kinship with primitive and archaic art.

Consequently, our work embodies these beliefs, it must insult anyone who is spiritually attuned to interior decoration; pictures for the home; pictures for over the mantel; pictures of the American scene; social pictures; purity in art; prize-winning potboilers; The National Academy, the Whitney Academy, the Corn Belt Academy; buckeyes, tripe, etc."

This manifesto of aesthetic beliefs clearly shows the dual influence of Surrealist thought and of modern, abstract art. The war had caused a number of leading European Surrealists to emigrate to New York, among them Max Ernst, Yves Tanguy, Robert Matta Echaurren, André Masson and André Breton. America's first year in the war, 1942, became the year of Surrealism in New York. The Museum of Modern Art showed Salvador Dalí and Joan Miró, and there was a series of one-man gallery shows with works by Masson, Ernst, Matta and Tanguy. The great pioneer of abstract art, Piet Mondrian, had moved to New York back in 1940. The critical discussion of his works and the arrival of the Surrealists were decisive steps in the rise of Abstract Expressionism. Rothko and Gottlieb saw themselves as the new, independent successors to the European avantgarde. They sought to unite Surrealism and abstract painting.

Rothko and Gottlieb's statement succeeded in setting off the public controversy they had hoped for. Rothko wanted to give painting the same kind of expressive power as music or literature. Music was his great love from childhood

*Untitled*, 1944/45
Graphite, brush, black ink and gouache on paper, 66 x 50.8 cm
Courtesy Christie's Images, New York

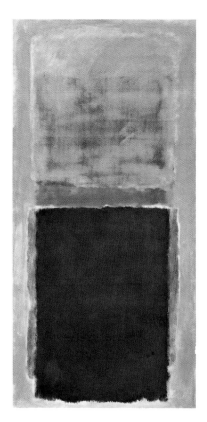

***Homage to Matisse***, 1954
Oil on canvas, 268.3 x 129.5 cm
Collection The Edward R. Broida Trust

on, his inspiration and consolation, at times his ecstasy. Like Arthur Schopenhauer, he took it as an elementary need and universal language. He could spend hours lying on the couch, listening to music. The intellectual provenance of the idea that painting should be viewed in the same way as music may be traced back to Friedrich Nietzsche. Rothko felt an affinity to the German philosopher, who found similar stimulation in listening to music.

Nietzsche believed that music is the true language of emotion. In *The Birth of Tragedy*, the philosopher writes that tragedy is the synthesis of the Dionysian and the Apollonian poles. Dionysus is the god of "the ineducable Art of music," Apollo of "the Art of the sculptor." To Nietzsche, tragedy articulates the conflict between the ecstatic primeval Dionysian experience of ancient cults, something above the individual; and the later visual depiction of this state through the Apollonian will to form. Tragic art with its link between melancholy and merriment, creates what Nietzsche called "metaphorical consolation." This yearning for a metaphysical world and glorification of the tragic myth, like Nietzsche's reverence for Aeschylus, all contributed to Rothko's later idea of art as drama.

To give to painting the emotion of music in Nietzsche's sense, Rothko took the visual dissolution of the human form, which by the 1940s had been completed, to further levels of abstraction. Publishing in *The Tiger's Eye* in October 1949, Rothko described the process as follows: "The progression of a painter's work, as it travels in time from point to point, will be toward clarity." His search for inspiration took him through the museums of New York, where he was thrilled with Miró, with Corot at the Metropolitan Museum, with Matisse's *The Red Room* at the MOMA. He studied it every day for months, and later believed it was the source of all of his own abstract pictures. When you look at it, he said, "you become that color, you become totally saturated with it"; it was like music. Later he called one of his paintings *Homage to Matisse* (ill. p. 38).

Rothko and his wife separated for the last time on June 13, 1943. Edith's business was doing very well at the time and she had even hired several employees to help her in making jewelry. She convinced Mark to work part-time at the store, but the artist felt humiliated by her demands. Their incessant crisis finally ended in divorce on February 1, 1944. Edith took several paintings as a settlement. Said Rothko, "Marriage is an impossible situation for an artist to engage in." Rothko was bitter about the divorce and battled a lengthy depression. Recovering, he went to his family in Portland and then to Berkeley, California, where he met Clyfford Still. They became friends two years later, when Still moved to New York.

Returning to New York in the fall of 1943, Rothko befriended Peggy Guggenheim, the great collector and patron of the arts, who had emigrated to New York in 1941 together with Max Ernst. Guggenheim had fled the Nazis because she was Jewish, whereas Ernst did so because the Vichy regime in southern France, where he had settled after leaving Germany in 1933, interned him after German forces moved into Paris. Guggenheim's artistic consultant, Howard Putzel, convinced her to show Rothko in her Art of This Century gallery, which she had opened in 1942, during the low point of the war. This is where Rothko met Max Ernst.

Photographer Aaron Siskind in 1944 introduced Rothko to Mary Alice (Mell) Beistle, who was 23 at the time and working as an illustrator for children's books at the McFadden publishing house. The two fell in love and were married on March 31, 1945. Contemporaries of Rothko's later said his first marriage was always doomed, because he as a romantic and Edith as a very pragmatic woman were of such different temperaments. Mell was young, pretty and warm-hearted, and admired Rothko as an artist in a way that Edith never did.

The following year, 1945, was a very promising one for Mark Rothko. In January, Peggy Guggenheim told him she wanted to put on his first one-man exhibition at her gallery. He sold only a few paintings, for prices ranging between 150 and 750$. The catalog text, written this time without a byline by Howard Putzel, read as follows: "Rothko's style has a latent archaic quality... Rothko's symbols, fragments of myth, are held together by a free, almost automatic calligraphy that gives a peculiar unity to his paintings – a unity in which the individual symbol acquires its meaning, not in isolation, but rather in its melodic adjustment to the elements in the picture. It is this feeling of internal fusion, of the historical conscious and subconscious capable of expanding far beyond the limits of the picture space, that gives Rothko's work its force and essential character. But this is not to say that the images created by Rothko are the thin evocations of the speculative intellect; they are rather the concrete, the tactual expression of the intuitions of an artist, to whom the subconscious represents not the farther, but the nearer shore of art."

But his grand hopes were dashed when the press once again delivered a disappointing verdict. The newspapers entirely ignored the event, while the art magazines published only brief reviews. Rothko thereupon wrote the following: "I insist upon the equal existence of the world engendered in the mind and the world engendered by God outside of it. If I have faltered in the use of familiar objects, it is because I refuse to mutilate their appearance for the sake of an action which they are too old to serve; or for which perhaps they had never been intended... I quarrel with surrealists and abstract art only as one quarrels with his father and mother; recognizing the inevitability and function of my roots, but insistent upon my dissent; I, being both they, and an integral completely independent of them."

He had broken philosophically with Surrealism in 1943, feeling that it no longer lived up to his own humanist ideals and was stuck too far in its emphasis on the unconscious and the objects of everyday life. In this regard, he wrote: "I love both the object and the dream far too much to have them effervesced into the insubstantiality of memory and hallucination. The abstract artist has given material existence to many unseen worlds and tempi. But I repudiate his denial of the anecdote just as I repudiate the denial of the material existence of the whole of reality. For art to me is an anecdote of the spirit, and the only means of making concrete the purpose of its varied quickness and stillness."

Works by Rothko were first taken up in the annual exhibition of contemporary art at the Whitney Museum in 1943, and he was represented in this important show for eight consecutive years up to 1950. He was called a "Mythomorphic Abstractionist" in the pages of *Art News*. The summer of 1946 saw his big breakthrough in California, where there were shows at the San Francisco Museum of Art and the Santa Barbara Museum of Art (ill. p. 25). He and Mell relocated temporarily to California, where he taught for a while at the California School of Fine Art. On seeing a group of works by Clyfford Still, he honored them as "new and beautiful abstraction. Still's show has left breathless both my students and everyone else I have met."

A native of North Dakota, Clyfford Still was cantankerous and outrageously self-confident, a tenacious opponent of any intellectualization in art, unapologetic about his fully abstract style. He believed in flows of energy and intuition and completely ignored all European developments, which he considered decadent to the bone. Rothko was deeply impressed by Still's aggressive arrogance and defiant rejection of all things European in painting, and of the art business

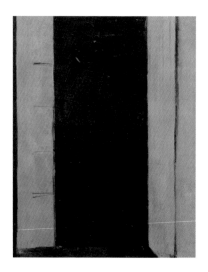

Henri Matisse
*French Window at Collioure,* 1914
Oil on canvas, 116.5 x 89 cm
Paris, Musée National d'Art Moderne,
Centre Georges Pompidou

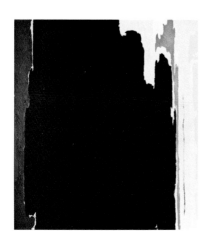

Clyfford Still
*Painting,* 1951
Oil on canvas, 237 x 192.5 cm
Detroit, Detroit Institute of Art

in general. This encouraged him to adopt a similarly uncompromising attitude in his own work.

Still's influence was thus vital at a time when Rothko himself had entered a phase of bold experimentation. Rothko began to visit Still regularly in his Greenwich Village studio after he moved to New York in the summer of 1945. Still's gigantic canvases were haunting, dim and raw, lacking any figuration, with large, unrefined, jagged-edged fields of dark color interspersed with a few patches shining bright (ill. p. 40). He once called these pictures "life-lines." On another occasion, he admitted that his flowing, often fire-like, vertical forms had been influenced by the plains of North Dakota. "These are living forms climbing out of the earth."

At the time Still in his personal artistic development was far ahead of Rothko or his friends, Gottlieb and Newman. He had left the Surrealists behind long ago. It was Rothko who got Peggy Guggenheim to offer Still a one-man show at her gallery. As Rothko and Still grew closer, Gottlieb and Newman were increasingly skeptical of this arrogant newcomer. Rothko himself wrote the text for Still's exhibition at Peggy Guggenheim's venue. Rumor has it that Still later said he was uncomfortable about this, fearing that Rothko was using him for his own purposes. The text described Still's paintings as "of the earth, the damned and of the recreated."

Another artist who attracted Rothko's attention was the young Robert Motherwell. Like Rothko, Pollock and Baziotes, Motherwell belonged to Guggenheim's stable, also known as the "small band of myth makers who have emerged here during the war." Rothko introduced Motherwell to his circle of painter friends: Barnett Newman, Adolph Gottlieb, Bradley Walker Tomlin and Herbert Ferber.

Rothko was invited to California for another teaching semester in 1947, at the School of Fine Arts in San Francisco. The students came to love him right away, seeing him as a true master of instruction. He found the atmosphere very stimulating, and this was to their benefit. That summer, Still and Rothko came up with the idea of founding their own, free school of art. They initiated the project the following year in New York, with David Hare, Robert Motherwell and William Baziotes, calling it "The Subjects of the Artist School." In the relatively short timespan of its existence (it was disbanded already in 1949), the school was successful as a lively forum for contemporary art in the United States. Motherwell at this time introduced Rothko to Bernard J. Reis, a tax attorney who specialized in executing and managing artists' wills, legacies, foundations and other tax-related business. His clients included Adolph Gottlieb, Franz Kline, Robert Motherwell, Willem De Kooning, Naum Gabo, William Baziotes, Larry Rivers, Theodoros Stamos and Jacques Lipchitz. Reis and his wife were enthusiastic collectors and accepted paintings as compensation for his services. He often put on big dinner parties for his artists at his house in New York. Conveniently, he was also the tax consultant for the Marlborough Gallery, a connection that proved both quite valuable and very destructive to Rothko.

Two new art publications started publishing in late 1947, *Tiger's Eye* and *Possibilities*. Rothko ended up writing for both, gaining a new platform for his beliefs and ideas. He published a key text on his own art, "The Romantics Were Prompted," in the Winter 1947–48 issue of *Possibilities*. This was his first and only comprehensive and independent statement on his own work. Said Rothko, "I see my pictures as dramas, their figures as actors. They arose from the need for a group of actors who can move on the stage without inhibitions or shame."

*Untitled*, 1944
Watercolor on paper, 100.3 x 69.9 cm
Collection Kate Rothko-Prizel

*Nocturnal Drama*, c. 1945
Gouache on paper, 55.9 x 40.3 cm
Courtesy Christie's Images, New York

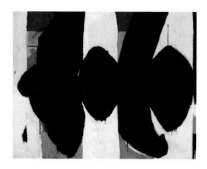

Robert Motherwell
*Elegy to the Spanish Republic No. 34,* 1953/54
Oil on canvas, 203 x 254 cm
Buffalo, NY, Albright-Knox Art Gallery,
Gift of Seymor H. Knox

He said that the greatest achievements of the century were those in which the artist took up the probable and mundane and showed the isolated figure of the individual, alone in his moment of greatest helplessness. The essay ended with the assertion that it didn't matter whether painting was abstract or figurative. "The point is to end this stillness and loneliness and to be able to breathe and stretch one arms again."

In an October 1949 article in *Possibilities*, he defined clarity as the elimination of all obstacles between the painter and his idea, or between the idea and the viewer. Once again, he described his own paintings as "dramas." His shapes begin "as unknown adventures in an unknown space" without "direct association with any particular, and the passion of organism." These texts were written just as Rothko was moving out of his mythical phase and beginning to systematically eliminate any figurative elements in his pictures. He spoke often of yearnings for transcendental experiences, which he ultimately saw as the content of his mature pictures.

A huge success came in the spring of 1946, when the young art collector Betty Parsons put on a show of Rothko's aquarelles at the Mortimer Brandt Gallery. Parsons opened up her own gallery just a half-year later and set up a one-man show for Rothko in March 1947. She got him under contract that same year, and Rothko gave her the exclusive rights to market his pictures. Now, at the age of 44, Rothko finally had his own gallery, in which he could regularly put on shows until 1951. This was most welcome, as his cumulative gross income for 1947 added up to 1,395 dollars, and that included his salaries as a teacher. While the works he showed at Betty Parsons in the years from 1946 to 1948 still carried certain Surrealist overtones, he was well on his way to experimenting with entirely new forms.

*No. 15*, 1949
Oil on canvas,
170 x 104.4 cm
Private collection

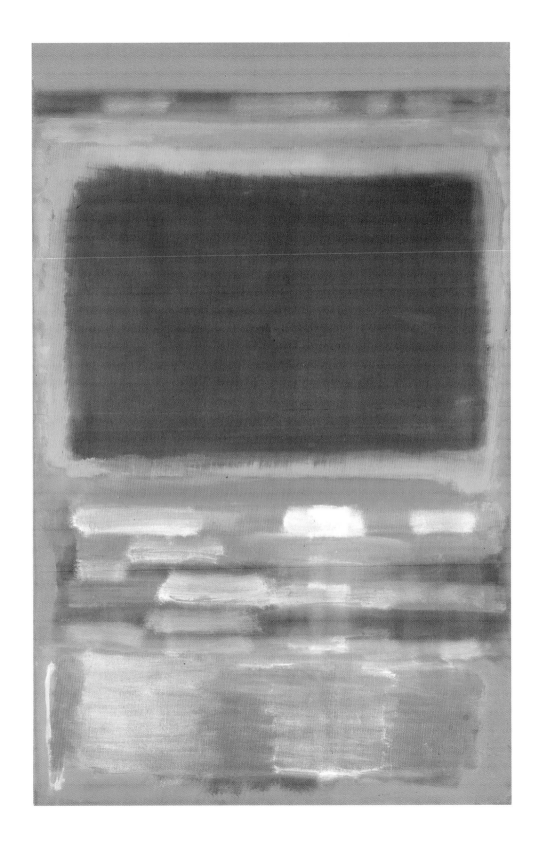

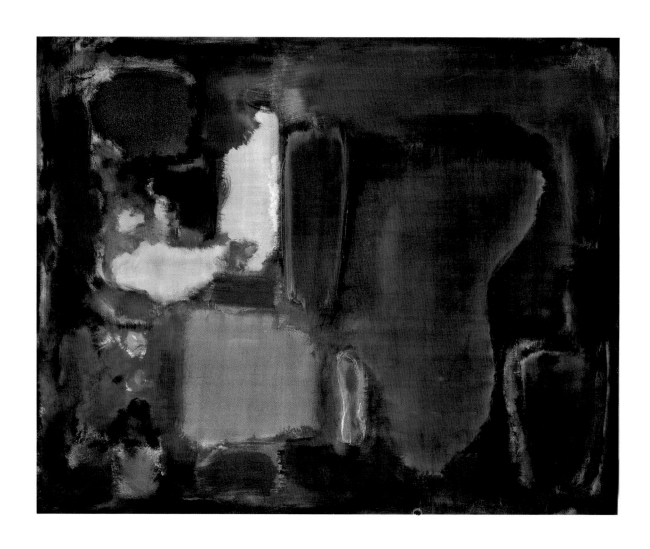

# Multiforms – The Way To The Classic Paintings

The year 1946 was a turning point in Rothko's artistic career. He created a new series of pictures, the "multiforms," which can be viewed as a bridge to his classic abstract paintings. He himself never used the word multiforms when referring to his works, but the term became common in art circles after his death in 1970. Rothko began to leave behind the themes of his previous works – myths and symbolism, landscapes and human figures – in favor of a more formless kind of pictorial communication. The biometric forms common to his works in the mid-forties gave way to multifarious, blurred color blocks lacking permanence or depth, and which seemed to grow organically from inside the picture itself. Rothko gave these color fields transparency and brightness by covering his canvasses with thin layers of paint. He called these forms "organisms... with the passion for self-expression," saying they begin to realize themselves exactly at the moment when the artist finishes his work. Rothko transferred a kind of life force to the objects in his pictures, making them into vessels for universal human expression: "I will say without reservations that from my view there can be no abstractions, any shape or area which [lacks] the pulsating concreteness of real flesh and bones. Its vulnerability to pleasure or pain is nothing at all. Any picture which does not provide the environment in which the breath of life can be drawn does not interest me."

Rothko spent the summer of 1948 mostly at East Hampton on Long Island. Near the end of his stay, the artist invited several friends and acquaintances to view his new multiforms. The art historian Harold Rosenberg remembers finding these works "fantastic," and called his experience "the most impressive visit to an artist" in his life. During the following winter, Rothko found his definitive style. After several months of crisis, heightened by the death of his mother Kate in October 1948, Rothko exhibited his newly matured painterly style for the first time in early 1949 at the Betty Parsons Gallery. The amorphous color spots of his "multiforms," which partly recalled physical objects, were now reduced to two or three rectangular and symmetrically overlaid color blocks. Rothko also adopted a much larger format for his pictures, separating the color blocks from the edges of the paintings to give the impression of colored fields which seem to hover in front of an undefined background.

The pictures for the exhibition no longer bore descriptive titles, as Rothko had used for his Surrealist phase. He never again utilized frames, titles, or

*No. 26*, 1948
Oil on canvas, 85 x 114.8 cm
Private collection

*No. 18*, 1948
Oil on canvas, 116.6 x 141 cm
Tel Aviv, Collection Joseph Hackmey

45

*Untitled*, 1948
Oil on canvas, 127.6 x 109.9 cm
Collection Kate Rothko-Prizel

descriptions for his works, merely numbers and dates. Some of his dealers added the names of the dominant colors of a particular work for a title.

From 1949 until 1956, Rothko painted almost exclusively in oils, using mostly vertical formats, in sizes that at times exceeded 300 cm in height. His wish was to use the proportions of the painting to create a feeling that the viewer was actually inside the picture: "I paint very large pictures. I realize that historically the function of painting large pictures is painting something very grandiose and pompous. The reason I paint them, however – I think it applies to other painters I know – is precisely because I want to be very intimate and human. To paint a small picture is to place yourself outside your experience, to look upon an experience as a stereopticon view or with a reducing glass. However you paint the larger picture, you are in it. It isn't something you command!"

Rothko thought that the ideal distance for observing his paintings was 45 centimeters. In this way, the viewer would feel himself drawn into the fields of color, experiencing their inner movement and absence of clear borders, and feel an awe for that which could not be understood, together with the freedom to overstep the very limits of human existence.

Although Rothko used the whole of the color spectrum, it should be noted that in each of his phases he tended to a particular hue. Before the mid-1950s he

seldom used dark blues or greens, preferring bright, radiating reds and yellows, which appeared sensuous or even ecstatic. Rothko usually mixed his paints himself. On the untreated, unprimed canvasses, Rothko, much like a designer of theater sets, brushed a thin layer of binder into which color pigments had been mixed, subsequently fixing this foundation with oils, which he allowed to spread around the unframed edges of the paintings. Over this "three-dimensional" priming, Rothko applied overlapping color mixtures, each so strongly thinned that their pigmentation barely clung to the surface of the picture. This procedure gave his paintings both transparency and luminance. The individual layers of

*Untitled*, 1948
Oil on canvas, 98.4 x 63.2 cm
Private collection

"What I liked about Rothko was that there was no real sort of idea in the paintings. They were a presence, just pure abstraction. When I think about Rothko, it's color first, the exuberance, the luminosity, and the radiance of color that is so striking. I'm not much interested in the dark paintings ... Rothko's sense of proportion shows in a painting, say of a large yellow with white over it, a thin portion of black at the top that has white over it mixed with gray, and then a very small black and red on the bottom, with a little bit of color left around the edge. Paint application is also crucial. I admire Rothko's brushwork ... With Rothko, you feel the way he caresses the canvas. His painting seems to absorb color and to glow."
ELLSWORTH KELLY, 1997

*No. 24 (Untitled)*, 1951
Oil on canvas, 236.9 x 120.7 cm
Tel Aviv, Tel Aviv Museum of Art,
gift of The Mark Rothko Foundation, Inc., 1986

color were applied with very light and fast brush strokes; he imagined that the colors were somehow "blown" onto the canvas. The nearly symmetrical underlying structures that Rothko developed in his classic paintings offered the possibility of many-sided color variations and an intensification of painterly expression, similar to the use of sonatas in music. The dramatic conflict in Rothko's pictures, however, was created through the tension of contrasting colors, which strengthened each other by their effect as well as by the tension of containment and eruption, of fixation and flotation, which Rothko described as tragic.

Early in 1950, Rothko traveled with his wife Mell to Europe, the first such trip since the family had emigrated from Russia. With the small inheritance Mell received on the death of her mother, the two were able to finance a five-month trip through England, France, and Italy, during which they visited the most important European museums. Rothko was a great admirer of European art, yet he continued to stress the autonomy of new American painting. Paris was a big disappointment for him, though he did have better impressions of Italy. Rothko was particularly impressed by the celestial light and meditative quiet of Fra Angelico's frescos in the monastery of San Marco at Florence. While in Rome, Mell discovered that she was pregnant. She gave birth to a daughter on December 30, 1950. They named the baby Kathy Lynn and called her Kate, after the American name of Rothko's mother.

Among other things, Rothko traveled to Europe in the hope of finding rejuvenation after the exertion of painting and the exasperation of selling his works. His relationship to the art scene in the early 1950s was conflicted. Although he was gaining increased recognition, he still was not earning enough to support his family. An important point of prestige for the artist was the sale of a painting for one thousand dollars to Mrs. John D. Rockefeller III, a purchase made possible through the connections of the architect Philip Johnson. Johnson was also responsible for obtaining the painting *Number 10*, 1950, and donating it to the Museum of Modern Art, after the wishes of its director, Alfred Barr. Barr wanted a piece by Rothko for the museum, yet knew that the curators would not agree to a purchase. For that reason he chose a detour through Johnson, as he could be sure that the curators would not refuse such a gift. In any event, the painting was kept in storage for two years, and A. Conger Goodyear, one of the founders of the museum, actually gave up his membership in an act of protest against the piece.

Aside from the solo exhibitions at the Betty Parsons Gallery in 1950 and 1951, in the early 1950s Rothko's works were represented at a large number of shows in the United States as well as in Tokyo, Berlin, Amsterdam, and São Paulo. In 1952 he was invited to participate in "Fifteen Americans," an exhibition at the Museum of Modern Art curated by Dorothy Miller. This show signaled the museum's acceptance of abstract art, as developed by Rothko and his colleagues Still, Pollock, and Baziotes, as the leading trend in American painting in the middle of the century. Rothko insisted on hanging and arranging the lighting for his paintings himself, giving rise to tensions with the curator, but the exhibition was very well received by the critics. A plan to send the exhibition on a European tour was canceled when Rothko raised objections to the idea of showing his work at other locations.

This exhibition caused disgruntlement between Rothko and Barnett Newman; Newman suggesting that Rothko had attempted to prevent Newman from participating. Originally bound by their will to assert themselves, with their growth in success and recognition the Abstract Expressionists began to fall apart as group. Internally, they began to squabble over positions of leadership, over

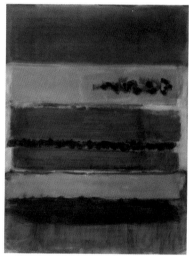

*No. 3 / No. 13 (Magenta, Black, Green on Orange)*, 1949
Oil on canvas, 216.5 x 163.8 cm
New York, The Museum of Modern Art, bequest of Mrs Rothko through The Mark Rothko Foundation, Inc., 1981

*No. 5 (Untitled)*, 1949
Oil on canvas, 215.9 x 160 cm
Norfolk, VA, The Chrysler Museum of Art, bequest of Walter P. Chrysler Jr.

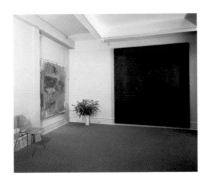

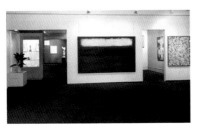

Installation in the Sidney Janis Gallery, New York, 1961 and 1964

*No. 61 (Rust and Blue) [Brown, Blue, Brown on Blue]*, 1953
Oil on canvas, 294 x 232.4 cm
Los Angeles, The Museum of Contemporary Art, The Panza Collection

matters of integrity and autonomy. After Rothko's art was declared to be a good investment by no less a financial authority than *Fortune* magazine, the relationship between Rothko and his uncompromising colleagues Still and Newman only worsened further in the mid-1950s. They accused Rothko of harboring an unhealthy yearning for a bourgeois existence, and finally stamped him as a traitor. Still wrote to Rothko to demand the return of all the pictures they had exchanged over the years, objecting that certain individuals had attempted to turn his works into capital. Rothko actually did return the paintings, and with this act, the friendship ended. The break with his companion of many years affected Rothko deeply, and despite efforts on his part the relationship never improved.

Rothko's financial situation slowly began to improve at the beginning of the 1950s. Aside from the regular salaries accruing from his teaching positions, among others at Brooklyn College, his art also began to make money for him. Rothko was invited to a solo exhibition at the Art Institute of Chicago in October 1954 by the institution's curator, Katherine Kuh. The museum then bought one of his paintings for four thousand dollars. At that point the highly successful New York art dealer Sidney Janis signaled an interest in taking Rothko on for his gallery, where he already represented Jackson Pollock and Franz Kline. Rothko left Betty Parsons to sign on with Janis, who showed 12 of Rothko's works at his gallery in 1955. This settled Rothko's status as a protagonist of international importance in the postwar art scene, artist Thomas Hess wrote. Like Betty Parsons, Janis allowed Rothko to hang his pictures himself. Only in the consideration of lighting did tension come and go between the artist and his gallerist. Rothko demanded dim light, feeling this would lend a mysterious quality to his paintings. From this point on, Rothko always insisted on a muted illumination of his works. At any rate, Sidney Janis marketed Rothko's paintings much more effectively than Betty Parsons had ever done, and even during the recession of 1958 he was able to sell 13 paintings for more than 20 thousand dollars. In the same year, Rothko was exhibited at the United States Pavilion of the 29th Biennale in Venice, which represented an important step in the assertion of American painting in Europe.

Despite this growing acceptance, Rothko often felt unappreciated, and liked to remark that others misunderstood him. Every attempt to interpret his works left the painter annoyed. Biographer James Breslin writes that Rothko wanted the "ego" in his paintings to remain difficult to grasp. He saw his forms as having a life of their own, something beyond material boundaries. "My art is not abstract, it lives and breathes," he said. And just as a picture can come to life in the presence of a sensitive viewer, so too might the reaction of the viewer be deadly. Beginning in 1950, Rothko stopped giving any explanations for his paintings. "Silence is so accurate," he said, adding that words would only "paralyze" the viewer's mind. In one conversation he said, "Maybe you have noticed two characteristics exist in my paintings; either their surfaces are expansive and push outward in all directions, or their surfaces contract and rush inward in all directions. Between these two poles you can find everything I want to say."

Rothko increasingly refused to be identified with the New York School. He hated just as much to be classified as a great colorist. In an interview with Selden Rodman he proclaimed, "You might as well get one thing straight. I'm not an abstractionist... I'm not interested in the relationship of color to form or anything else. I'm interested only in expressing basic human emotions – tragedy, ecstasy, doom, and so on. And the fact that a lot of people break down and cry when

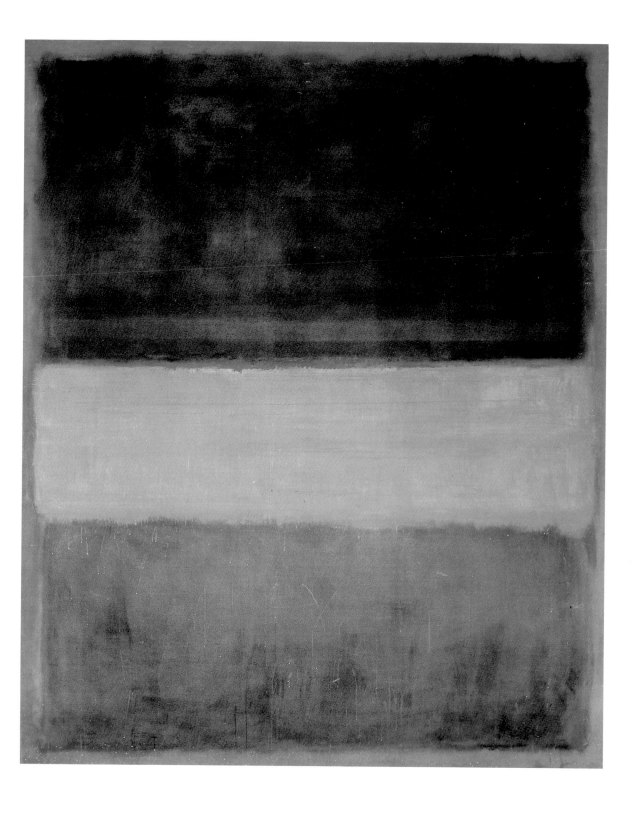

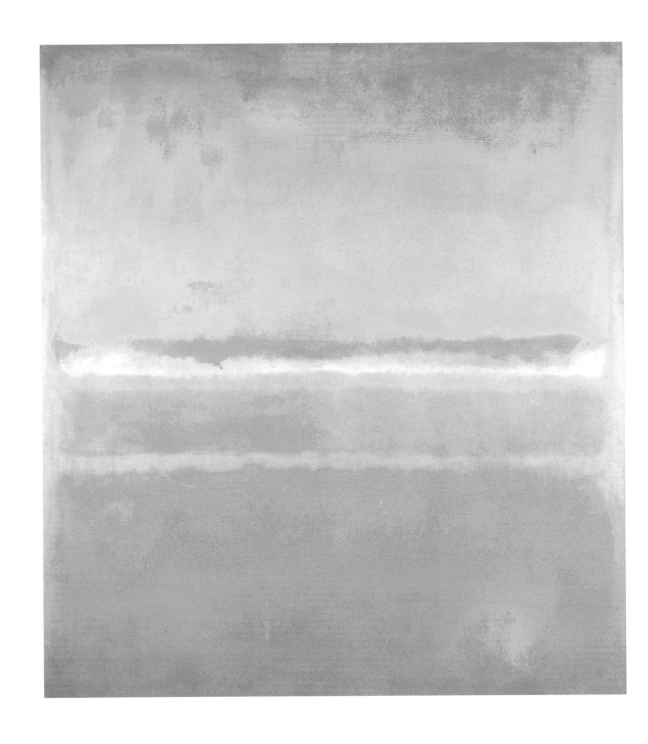

*No. 14 / No. 10 (Yellow Greens)*, 1953
Oil on canvas, 195 x 172.1 cm
Los Angeles, Estate of Frederik R. Weisman

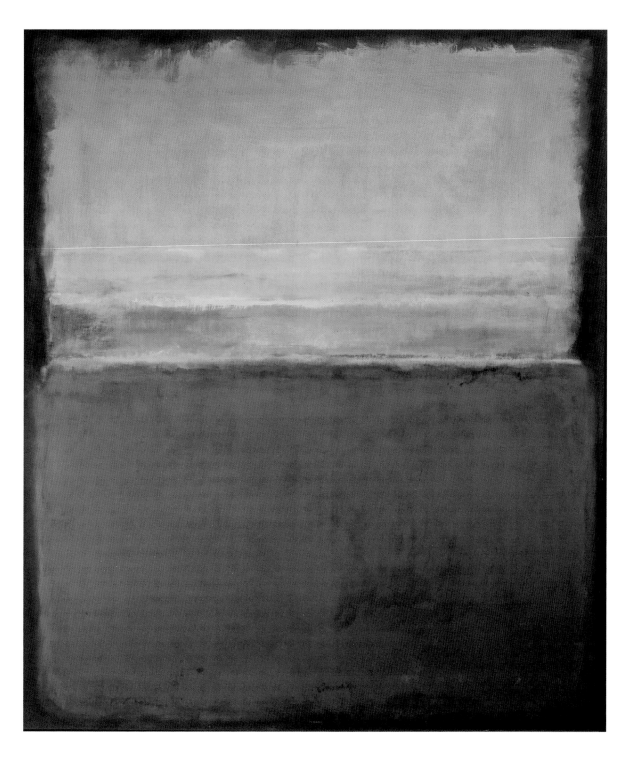

*No. 2 (Blue, Red and Green)[Yellow, Red, Blue on Blue]*, 1953
Oil on canvas, 205.7 x 170.2 cm
Switzerland, private collection

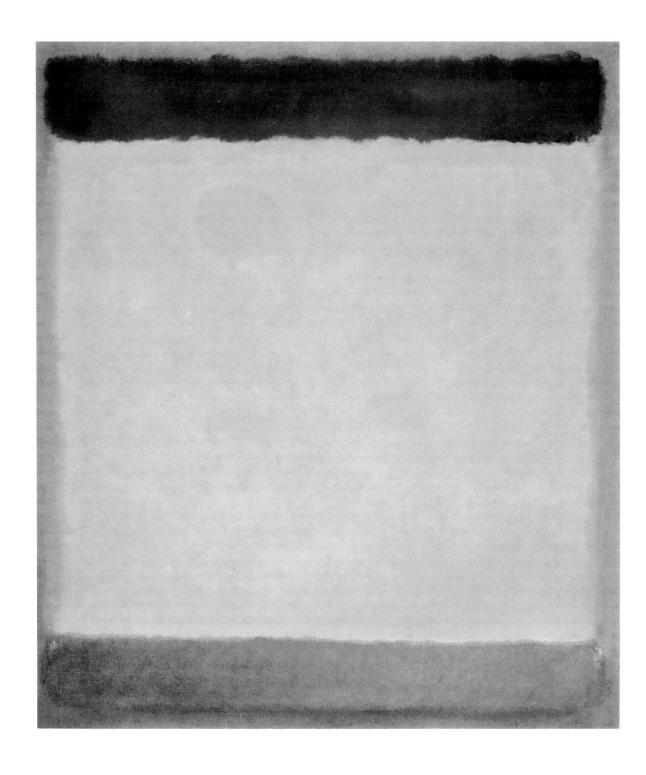

ABOVE:
***Untitled (Blue, Yellow, Green on Red)***, 1954
Oil on canvas, 197.5 x 166.4 cm
New York, The Whitney Museum of American Art

RIGHT:
***Saffron***, 1957
Oil on canvas, 177 x 137 cm
Liechtenstein, private collection

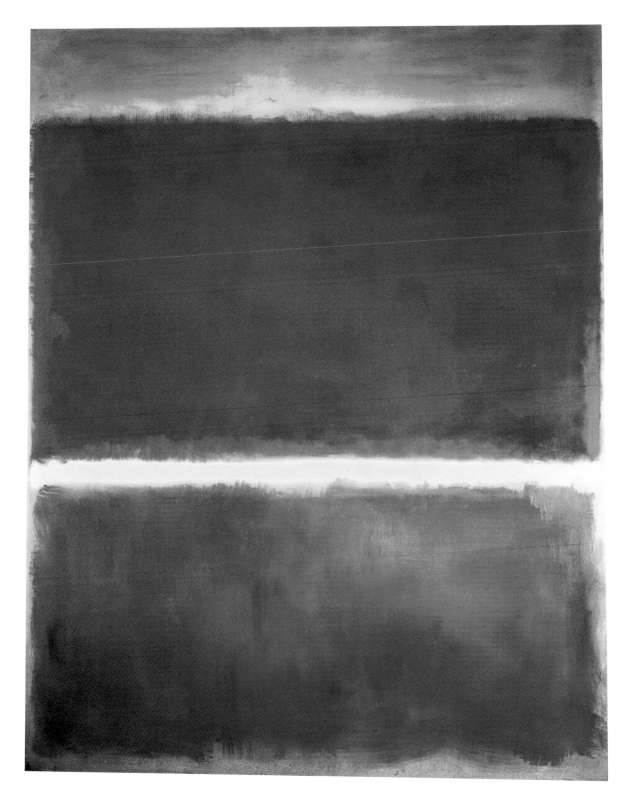

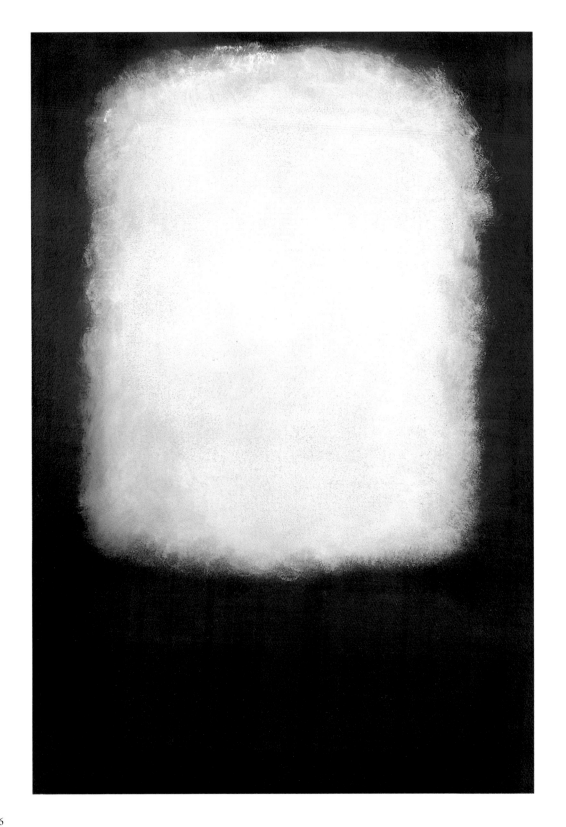

confronted with my pictures shows that I can communicate those basic human emotions... The people who weep before my pictures are having the same religious experience I had when I painted them. And if you, as you say, are moved only by their color relationship, then you miss the point."

In fear of being described too one-dimensionally, Rothko deliberately denied that the medium of color interested him, although it was plain that color was his primary source of expression. "Since there is no line," he told Elaine De Kooning, "what is there left to paint with? ...color... [is] merely an instrument." On another occasion, he announced that, "A painting is not about experience. It is an experience."

The formal tools of his trade served Rothko merely as instruments to relate an experience of transcendental reality. For him, the spatiality of color, or color fields, held mythical powers, which transported themselves to the viewer. Beginning in 1957 and continuing into his later years, Rothko tended to adopt an increasingly dark palette. He used fewer reds, yellows, and oranges, instead choosing less bright colors such as brown, gray, dark blue, and black. Rothko's paintings at a solo exhibition at the Sidney Janis Gallery in 1958 were indeed less accessible, gloomier, more mysterious.

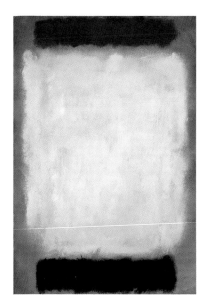

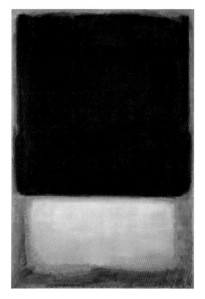

*Untitled (White on maroon)*, 1954 (1959?)
Oil on paper, mounted on masonite,
96.5 x 63.5 cm
Private collection

*No. 7 (Dark over Light)*, 1954
Oil on canvas, 228.3 x 148.6 cm
California, The Semel Collection

PAGE 56:
*Untitled*, 1959
Oil on paper, mounted on masonite,
95.8 x 62.8 cm
Private collection

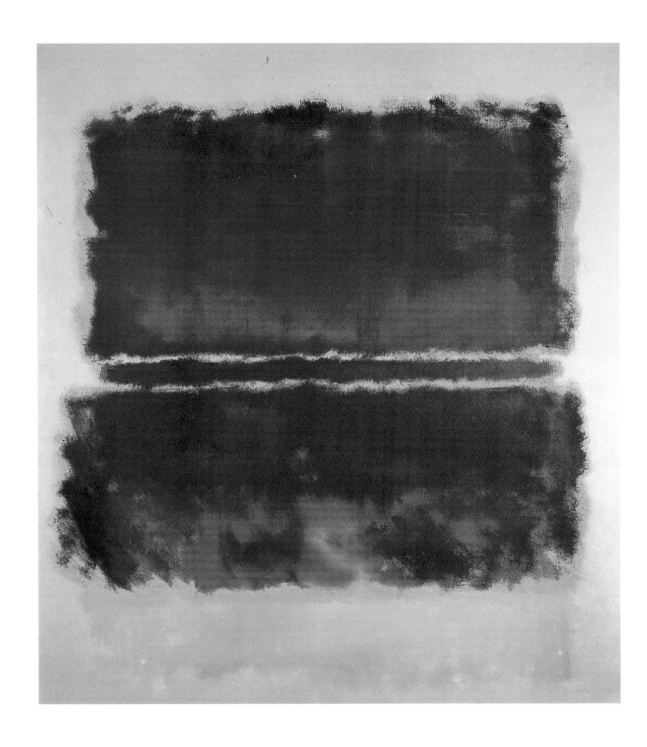

ABOVE:
*No. 15*, 1952
Oil on canvas, 232.4 x 210.3 cm
Private collection

RIGHT:
*Untitled,* 1952
Tempera on paper, 101.9 x 68.7 cm
Collection Christopher Rothko

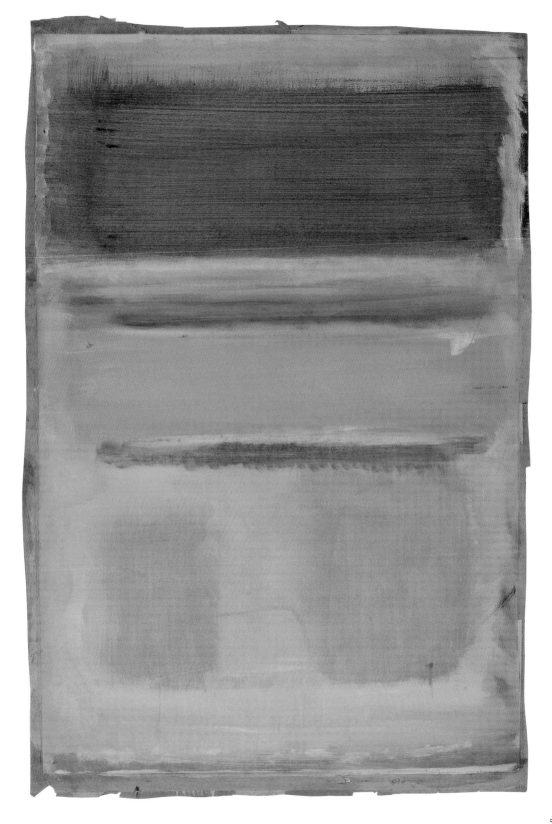

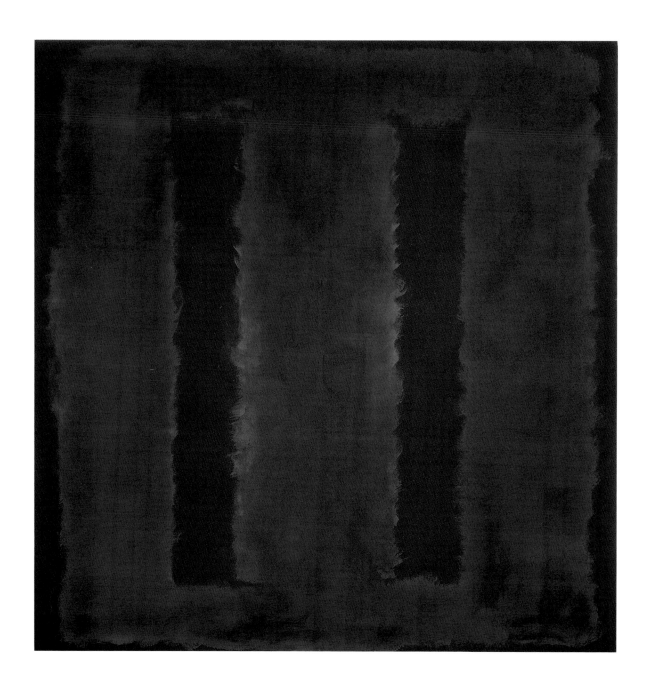

# Rothko's Murals And
# The Rise Of Pop Art

Rothko was commissioned in mid-1958 to furnish the newly finished Seagram Building on Park Avenue in New York with wall paintings. The edifice, designed by Mies van der Rohe and Philip Johnson, is today still the headquarters of the tradition-rich beverage company Joseph E. Seagram & Sons. Rothko received the contract on June 25, requiring him to "decorate" an area totaling roughly 50 square meters. A fee of 35 thousand dollars was negotiated, including a down payment of seven thousand, with the rest to be paid in installments over the next four years. The room Rothko was to decorate was that of the Four Seasons restaurant, foreseen as a noble eatery for elite management. This was to be the first time that Rothko would design a related series of paintings, as well as the first time he would create works for a specific room. The Four Seasons dining hall was long and narrow. In order for his pictures to be seen, they would need to be hung over the heads of the diners, and not, as Rothko had previously favored, be placed just above the floor.

During the months in which he worked on the Seagram murals, he completed three series of gigantic wall paintings, approximately 40 works in all, and for the first time in 20 years made painted sketches as studies. He used a warm palette of dark red and brown tones, breaking the horizontal structure of his pictures by turning them at 90-degree angles. In this way he created a work that would relate directly to the architecture of the room. The surfaces of color recalled architectural elements, as columns, walls, doors and windows, giving the viewer a feeling of confinement, yet presenting him with an unreachable world beyond.

Rothko chose to take a break from his work on the murals in June 1959, a full year into the project. He decided to travel with his family to Europe, taking them over the Atlantic by ship. On board the SS Independence he met John Fischer, then publisher of the venerable *Harper's Magazine*. The two became fast friends, and Rothko eventually confided in Fischer that he took the commission for the Seagram Building in the hope of "painting something that will ruin the appetite of every son-of-a-bitch who ever eats in that room. If the restaurant would refuse to put up my murals, that would be the ultimate compliment. But they won't. People can stand anything these days." Fischer wrote about their encounter after Rothko's death, quoting him as follows: "I hate and distrust all art historians, experts, and critics. They are a bunch of parasites, feeding on the body of art. Their

***Mural Sketch (Seagram Mural Sketch)***, 1959
Oil on canvas, 182.9 x 228.6 cm
Chiba-Ken, Japan, Kawamura Memorial
Museum of Art

***Untitled (Deep Red on Maroon) [Seagram Mural Sketch]***, 1958
Oil on canvas, 264.8 x 252.1 cm
Chiba-Ken, Japan, Kawamura Memorial
Museum of Art

work not only is useless, it is misleading. They can say nothing worth listening to about art or the artist. Aside from personal gossip, which I grant you can sometimes be interesting." Despite this oft-expressed antipathy for art critics, it seems as if Rothko hoped first and foremost to make an impression on his new acquaintance with his polemics. The painter's comments reveal a deep-seated discomfort in "decorating" the pompous, elite restaurant.

The Rothko and Fischer families went ashore at Naples and visited Pompeii. According to Fischer, Rothko saw "a deep relationship" between his current work at Seagram's and the antique murals in the Villa di Misteri. The Rothkos traveled on to Rome, Florence, and Venice. In Florence, Rothko sought out the Michelangelo-decorated library in San Lorenzo, just as he had during an earlier trip in 1950. In a later interview with Fischer, Rothko admitted that the feeling of space created by Michelangelo's wall paintings in the building's stairwells were a source of inspiration for his Seagram murals. "This room had exactly the feeling that I wanted," Rothko said. "It gives the visitor the feeling of being caught in a room with the doors and windows walled-in shut." From Italy, the family continued to Paris, Brussels, Antwerp and Amsterdam, finally leaving from London to return to the United States on the ocean liner Queen Elizabeth II.

After their return, Mark and Mell went one night to have dinner at the Four Seasons. He was so incensed at the pretentious ambiance that he decided to give up the project on the spot. By that time, in 1960, the artist was earning enough

*Seagram Murals, Rothko Room –*
*Seven Murals,* 1958
Interior
Chiba-Ken, Japan, Kawamura Memorial
Museum of Art

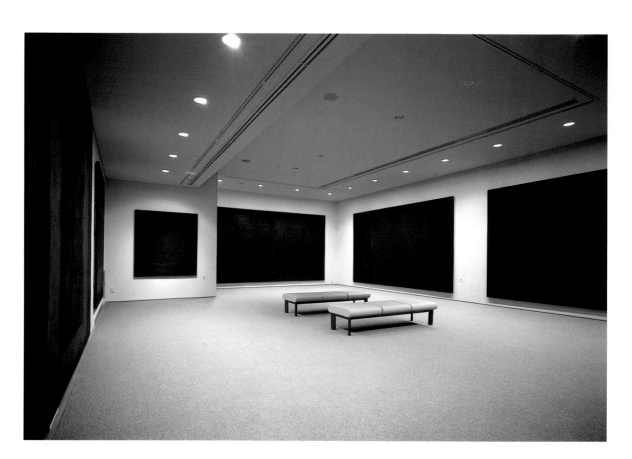

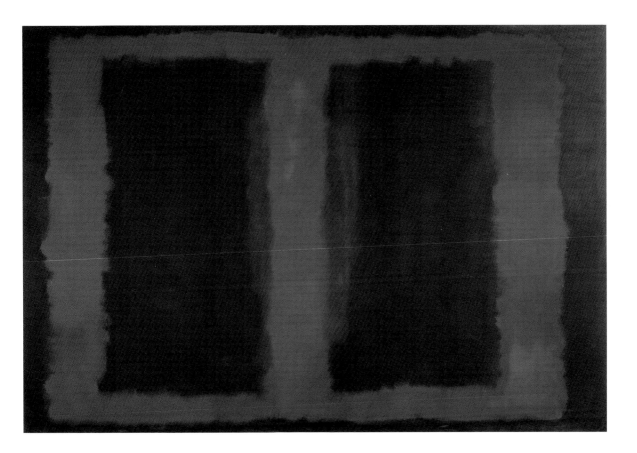

money to be able to return the advance he had received and simply keep the paintings for himself. The recall of the Seagram murals created a stir in the press and was followed with interest. Today we can no longer reconstruct Rothko's original presentation concept, because these paintings have been scattered all around the world. Nine hang at the Tate Gallery in London, a second grouping at the Kawamura Memorial Museum in Japan and with others in the collections of the National Gallery of Art in Washington, DC, and of the Rothko children.

One of Rothko's closest friends at this time was the poet Stanley Kunitz. The two met often to discuss the moral dimensions of poetry and art. "In the best painting," Kunitz said, "as in authentic poetry, one is aware of moral pressures exerted, an effort to seek unity in the variety of experience. Choices are important. Moral pressure exists to make right and wrong choices." The friendship with Kunitz had a positive effect on Rothko. They both agreed that art constitutes a moral universe. "I felt definite affinities between his work and a kind of secrecy that lurks in every poem," Kunitz later said.

Rothko's name was perpetually increasing in notoriety. More and more museums and private collectors lined up to purchase his works. Among the visitors to his studio were the collector Duncan Phillips of Washington and his wife, Marjorie. Phillips organized solo exhibitions for Rothko in 1957 and 1960 at his home in Washington, in a space which also served as a museum for his own collection. In 1960, Phillips bought four paintings from Rothko in order to fill a

*Sketch for "Mural No. 4" [Orange on Maroon]*
*(Seagram Mural Sketch),* 1958
Oil on canvas, 265.8 x 379.4 cm
Chiba-Ken, Japan, Kawamura Memorial
Museum of Art

After the British sculptor Henry Moore had visited Rothko's exhibition in London at the Whitechapel gallery in 1965, he is said by Dore Ashton to have remarked that it was his most informative encounter with modern painting since his discovery of Cézanne, Picasso, Matisse and the Cubists in his youth.
HENRY MOORE, 1965

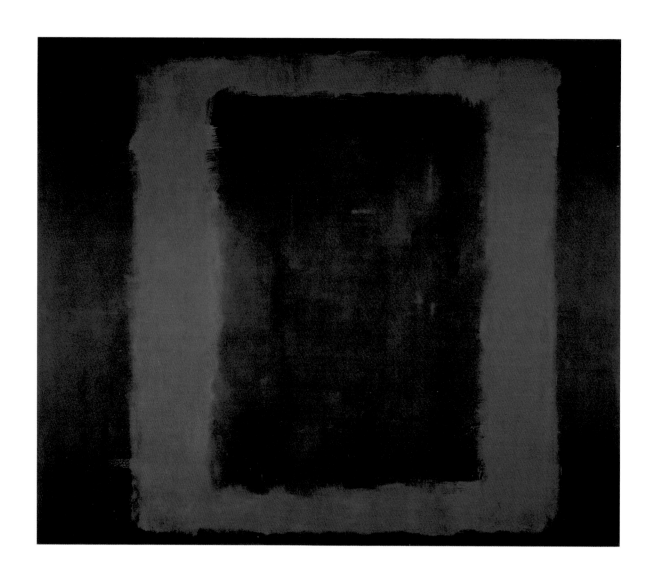

*Sketch for Mural No. 1 (Seagram Mural Sketch)*, 1958
Oil on canvas, 266.7 x 304.8 cm
Chiba-Ken, Japan, Kawamura Memorial Museum of Art

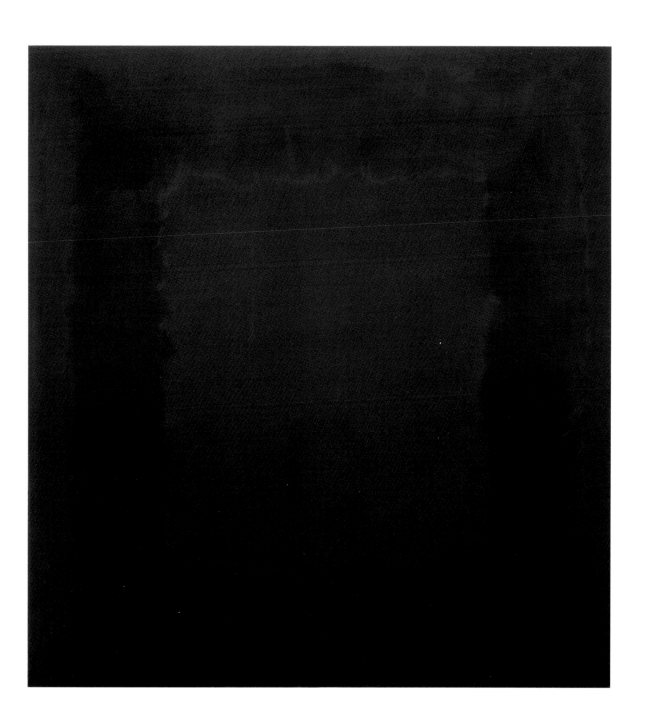

***Mural Sketch (Seagram Mural Sketch)***, 1958
Oil on canvas, 167.6 x 152.4 cm
Chiba-Ken, Japan, Kawamura Memorial Museum of Art

"Rothko Room" in his newly expanded space. The Phillips Collection was thus the first space in which Rothko could realize a dream that possessed him during the last decade of his life: to completely control both room and observer, so that the latter would be given the chance to experience the paintings on an immediate level, both physically and emotionally (ill. p. 67).

Another pair of collectors, Dominique and John de Menil, oil-rich patrons of the arts from Houston, Texas, took a pilgrimage to meet Rothko in New York. Rothko also picked up a buyer in David Rockefeller, scion of the astronomically rich Rockefeller empire and director of the Chase Manhattan Bank. By 1960, as the prices fetched for his paintings began to climb dramatically, Rothko was already 57 years old. With prices going as high as 40 thousand dollars for a single picture, he and Mell could finally afford a townhouse.

The artist felt himself deeply honored by the invitation to attend the inauguration in January 1961 of John F. Kennedy as the 35th president of the United States. Rothko traveled to Washington by train, together with Franz Kline and his girlfriend, Elizabeth Zogbaum. Following the ceremony, they were invited to attend a ball where they were seated next to the president's father, Joseph Kennedy. In the same year, the Museum of Modern Art held a retrospective of Rothko's works, encompassing 48 paintings. The curator of the exhibition was Peter Selz, who in his essay for the catalog wrote: "Celebrating the death of civilization… [Rothko's] open rectangles suggest the rims of flame in containing fires, or the entrances to tombs, like the doors to the dwellings of the dead in Egyptian pyramids, behind which the sculptors kept the kings 'alive' for eternity in the Ka. But unlike the doors of the dead, which were meant to shut out the living from the place of absolute might, even of patrician death, these paintings – open sarcophagi – moodily dare, and thus invite the spectator to enter their Orphic cycles. Their subject might be death and resurrection in classical, not Christian mythology: the artist descending to Hades to find the Eurydice of his vision. The door to the tomb opens for the artist in search of his muse."

The exhibition was a great success. Rothko visited his own MOMA retrospective daily, observing his paintings intensely. In its wake, he gave a number of his paintings to a traveling exhibition for subsequent display in London, Amsterdam, Brussels, Basel, Rome, and Paris. The same tour later went on to various American cities.

But with the Sixties the star of Abstract Expressionism in America began to wane. Young artists such as Andy Warhol, Roy Lichtenstein, Tom Wesselmann, and James Rosenquist among others took to a British import called Pop Art, developing it into new, previously unseen forms. Pop Art came from the visual world of mass media and advertisement. With its provocative use of the commonplace, the base and profane, Pop Art's popularity spread with lightning speed. The abstract art that had come to dominate the postwar scene suddenly appeared unyielding, haughty, and elitist. Many among the old New York School of Abstract Expressionists saw the new movement as a kind of "anti-art." Rothko described the Pop artists as "charlatans and young opportunists." But the critics interpreted the rise of Pop Art as marking the end of Abstract Expressionism, which they now retroactively declared long out of date. Sidney Janis took up the new movement in 1962, exhibiting the latest works of several Pop Art newcomers, as well as of a group of French artists around Yves Klein, Arman, and César, who became known as the New Realists and who were promoted by the French art historian and critic Pierre Restany. On seeing the show, Rothko, Franz Kline, Motherwell and De Kooning all left the Janis Gallery in a rage. Rothko

"The paintings were a shock. They were so serious, not wild like Warhol. Rothko's attitude with regard to painting and the job of the painter was particularly impressive to me … At that time I really felt quite mixed about his work. It was both too holy and too decorative. Although the paintings apparently had a transcendental aspiration, they were used for decorative purposes, and looked overly beautiful in collectors' apartments."
GERHARD RICHTER, 1997

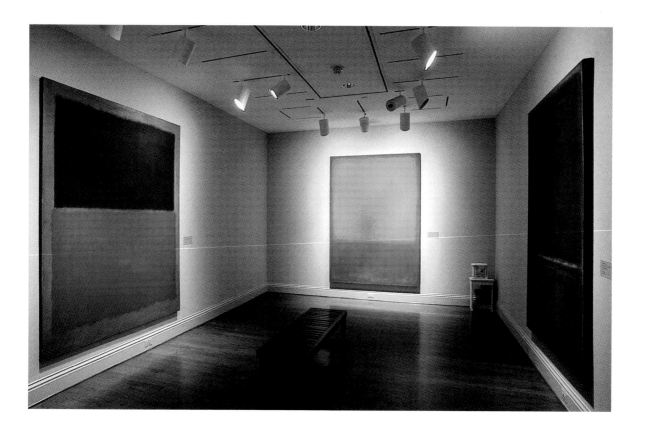

summed up their anger in the crisp question: "Are these young artists plotting to kill us all?"

Around this time Rothko got another opportunity to design a public room exclusively with his own paintings. He negotiated a deal with Harvard University to design a series of wall paintings for the planned penthouse of the Harvard Holyoke Center, a building to be constructed by the Spanish architect José Luis Sert. The paintings were to be a gift of the artist, although Harvard reserved the right to refuse the works if it chose. Rothko finished 22 sketches, from which five murals were created and later installed in the Holyoke Center. These consisted of a triptych and two large single wall paintings, in which Rothko took up and developed the portal images he originally conceived for the Seagram Building. All the paintings had a dark red background, which varied in color and contrast according to the number of layers of color applied over the foundation.

Just as Rothko finished these murals, he received a visit at his New York studio from Harvard president Nathan Pusey, a man who understood little about contemporary art. Pusey wanted to inspect and approve the works. The artist welcomed the president at the studio with a glass of whiskey, and after a lengthy discussion Rothko asked for his verdict. Pusey, a mid-western Methodist, vacillated before finally answering that he found the paintings "very sorrowful." Rothko countered that the dark emotion created by the triptych was intended to reflect the suffering of Christ on Good Friday, while the two somewhat brighter pictures were meant to invoke Easter Sunday and the Resurrection. Pusey grew quite excited and impressed with Rothko's explanations, believing these revealed

The Rothko Room
Phillips Collection, Washington, DC

*Five Studies for the Harvard Murals,*
c. 1958–1960
Tempera on colored construction paper,
various sizes
Private collection

the artist to be a philosopher with a universal vision and message. Returning to Cambridge, he recommended that the board of trustees approve the paintings, which were hung in January 1963 with the artist himself present. When the dining room underwent renovation a short time later, the murals were removed to the Guggenheim Museum in New York for an exhibit from April 9 to June 2, 1963. At the end of the exhibition Rothko returned again to Harvard, in order to once more oversee the installation of his works. The arrangement and especially the lighting of the room was quite bothersome to the artist's eye. An attempt was made to curb the negative effects of sunbeams through the protection of fiberglass shades, with only limited success. When the work was finally finished in early 1964, Rothko still remained "very unhappy with the whole." The sunlight so weakened the deep red of the paintings that the original effect of the works could only be appreciated on slides. In the end, the deeply scratched and discolored murals were removed in 1979 and stored in a dark room.

As Rothko approached his sixtieth birthday and his wife became forty-one, the couple brought a new child to the world, a son they named Christopher Hall, on August 31, 1963. In the same year, Rothko at the urging of his tax and financial advisor Bernard Reis signed a contract with Frank Lloyd, the owner of the Marlborough Gallery in New York. The contract gave Lloyd exclusive rights to Rothko's works outside of the United States. Lloyd's up and coming gallery would represent the artist in Europe, while Rothko would continue selling paintings himself from his New York studio. What appeared at the time to be a lucrative business relationship turned into one of history's largest art scandals after the artist's death, when the veil was lifted on a complex of double-buying, deception, betrayal, fraud, greed and cover-up. For many years, Rothko did not realize that Bernard Reis was also an accountant for the Marlborough Gallery, and was using that position to play a double game on him.

"With the public recognition he was gradually gaining Mark started to loose control. More and more collectors, curators and museum directors wanted to meet him, to visit his studio, and to buy his paintings. He felt insecure and inhibited. When I bought one of his pictures he knew that he meant something to me – was I not 'crazy'? But the new collectors were a puzzle to him; he never knew whether they really liked the work, or whether they merely wanted a 'new Rothko,' another feather in their crown."
BEN HELLER, 2001

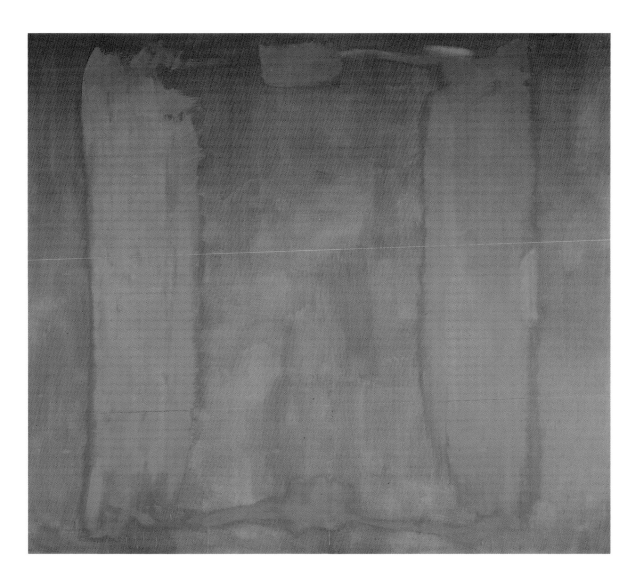

*Panel One (Harvard Mural Triptych)*, 1962
Oil on canvas, 267.3 x 297.8 cm
Harvard, Fogg Art Museum,
Harvard University Art Museums,
gift of the Artist

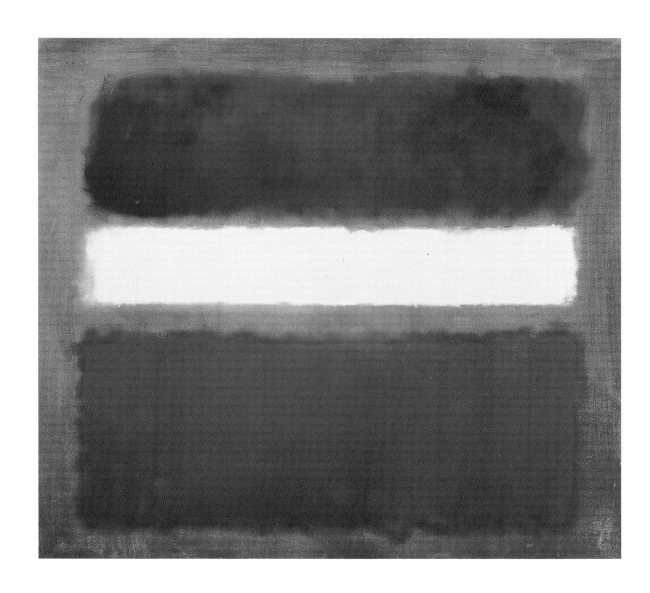

*No. 8 (White Stripe),* 1958
Oil on canvas, 207 x 232.4 cm
Private collection

RIGHT:
*No. 207 (Red over Dark Blue on Dark Gray),* 1961
Oil on canvas, 235.6 x 206.1 cm
University of California, Berkeley Art Museum, gift of the artist

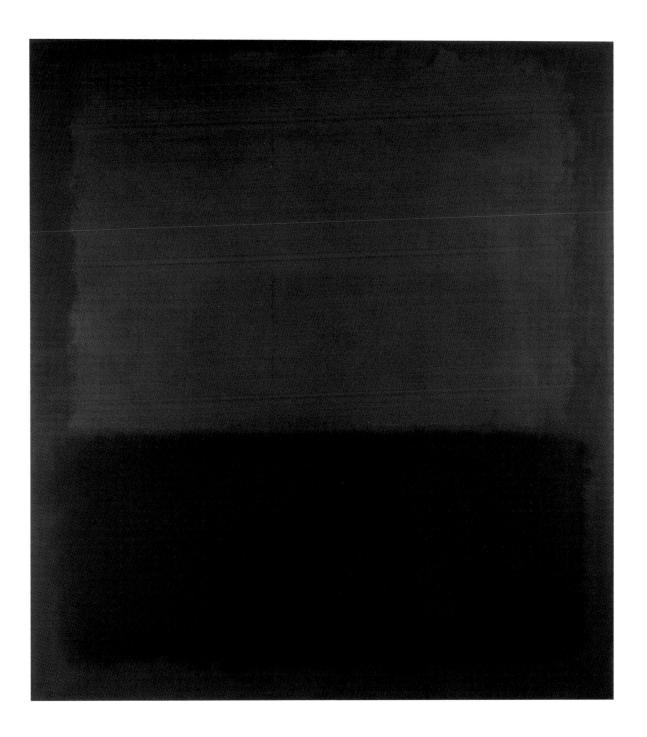

# The Rothko Chapel And
# The Tate Gallery Room

John and Dominique de Menil of Houston were both impressed with Rothko's work, in particular with his Harvard murals and the paintings for the walls of the Seagram Building, which they had seen in Rothko's studio. Early in 1965, the two gave the artist 250,000 dollars in commissions for a series of large wall murals. These were intended for a chapel which the de Menils planned to build for St. Thomas Catholic University in Houston, where Dominique de Menil was the director of the Art Department. Rothko was overjoyed with the project. Wishing them a happy new year in 1966, he wrote: "The magnitude on every level of experience and meaning of the task in which you have involved me, exceeds all my preconceptions, and it is teaching me to extend myself beyond what I thought was possible for me. For this, I thank you."

When Rothko began to work on the Houston Chapel paintings in the fall of 1964, he had just completed a move to his last studio, at 157 East 69th Street in Manhattan. He outfitted the space with pulleys holding parachute-type materials, allowing him to regulate the light. The studio was housed in a coach house with a central cupola, which allowed daylight to enter. The room was 15 meters high and inside, Rothko built provisional partition walls to the specifications of those which he would find in the planned chapel. Rothko worked intensely on the project throughout that fall, and indeed he was occupied by little else throughout 1967. He told friends that this would become his most important artistic statement. He was even allowed the right to participate in decisions relating to the architectural design of the chapel. He suggested an octagonal foundation, similar to a baptismal chapel, so that the congregation would be encircled by his murals. Light should fall from a cupola in the middle of the chapel and be filtered by reams of light fabric, just like in his new Manhattan studio. In addition, Rothko suggested a simple, unpretentious structure, one that would put his murals in the foreground. Although the renowned architect Philip Johnson was originally chosen to design the building, he was forced to give up his charge in 1967 at the insistence of Rothko, as the two could not come to terms over the design of the rooms. Two new architects were chosen in Howard Barnstone and Eugene Aubry of Houston, who finished the plans according to Rothko's wishes. The replacement architects flew to New York on many occasions, even bringing a model of the chapel with them. Every detail needed to be approved by Rothko himself.

*Untitled*, 1969
Oil on paper on linen, 178.4 x 109.2 cm
Courtesy James Goodman Gallery, New York

Rothko Chapel, Houston, Texas
*Broken Obelisk*, sculpture by Barnett Newman

73

Franz Meyer describes a visit in the atelier in 1965 when "in the large space on 69th Street the sham architecture had just been built whose blueprints corresponded to those of the chapel in Houston. Subsequently Rothko showed the first large-format Chapel Painting, which today hangs on the southern wall of the chapel between the entrance doors: a narrow vertical format in whose upper four-fifths the deep black of a rectangle, the wine-red black of the ground crowds against the edges. In the reproduced octagonal room in the studio, it hung alone bathed in a flooding yet at the same time gentle light. I was very moved by this sole giant painting. It was the first work of new art I had seen where I felt that I was getting a direct glimpse of the Divine."
FRANZ MEYER, 1997

For his oversize murals Rothko chose a dark palette. A number of assistants, on whom Rothko was now dependent owing to physical restrictions, helped the artist by spanning the prepared frames with cotton-based canvas. As Rothko wanted the oil paint to be watery, it was thinned to a large degree with turpentine. Under his direction the assistants applied the chestnut-brown paint in quick strokes across each surface. In total, he produced 14 large-format paintings, in three triptychs and five individual works, together with a voluminous collection of sketches and studies. Half of the Houston paintings were finished as monochromes, a first for the artist. The other half he painted with black rectangles, whose sharp borders represented another novelty. Rothko, for the first time, had foregone the sensuous, enticing effect of his "color clouds" with their soft, nebulous edges. The central wall of the chapel contained a monochrome triptych in soft brown tones. The pair of triptychs to the left and right held rectangles in opaque black. Four individual paintings were placed between the three triptychs, and a further individual painting was located directly opposite the central triptych. During the execution of the work, Rothko often invited acquaintances to his studio to hear their opinions. He was apparently uncertain of his new approach, as these works were much more hermetic and distanced than anything which he had previously completed. The series of paintings were finished by the end of 1967 and brought to a storeroom, where they were to be housed until the completion of the chapel.

Rothko continued this exploration of dark colors in the last two years of his life. The Black on Gray canvases of 1969–1970 (ill. pp. 17, 90) and large scale Brown on Gray works on paper (ill. p. 89) maintain the sombre mood of the Chapel Murals, and like those works, keep the viewer at a distance. In a major departure for Rothko, however, they do not share the murals' meditative aura; their gray portions contain an action and turbulence not seen in Rothko's work in more than twenty years. And while it is tempting to see these dark paintings as the expression of Rothko's severe depression, one must also note that he was painting large works on paper in pastel blues, pinks and terracotta on white backgrounds (ill. p. 84) during his final months.

In 1969 the de Menils purchased the Newman sculpture, *Broken Obelisk*, and had it placed in a reflecting pond next to the chapel (ill. p. 72). The sculpture was a monument to Dr. Martin Luther King, the American civil rights leader murdered one year before. Newman, like Rothko, died in 1970. Neither artist lived to see the dedication of the ecumenical chapel, which opened to the public on January 26, 1971, exactly one year after Rothko's death, with a group of leading Catholic, Jewish, Buddhist, Muslim, Protestant and Greek Orthodox clerics in attendance. A cardinal was dispatched from Rome to represent the pope.

Dominique de Menil's dedication speech deserves to be quoted at length:

"I think the paintings themselves will tell us what to think of them – if we give them a chance. They will educate us to judge them. Every work of art establishes its own base for criticism. Every work of art creates the climate in which it can be understood …

Everywhere where creative people are trying to open a new door, there is always more than meets the eye in an authentic work of art. At first we might be disappointed at the lack of glamour of the paintings surrounding us.

The more I live with them, the more impressed I am. Rothko wanted to bring his paintings to the greatest poignancy they were capable of. He wanted them to be intimate and timeless. Indeed they are intimate and timeless. They embrace us without enclosing us. Their dark surfaces do not stop the gaze. A light surface

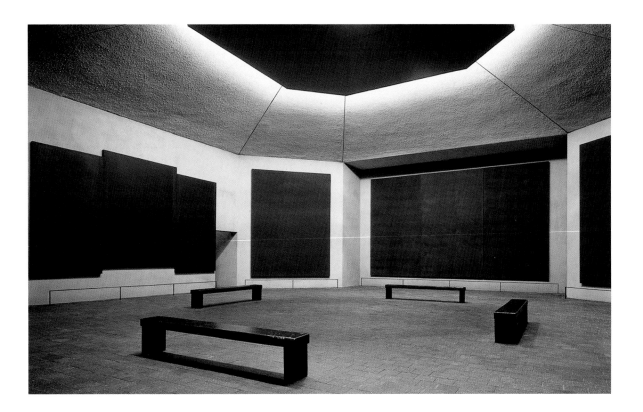

Rothko Chapel, Houston, interior view

is active – it stops the eye but we can gaze right through these purplish browns, gaze into the infinite. They are warm too.

There is a glow in the central panel. Rothko told me that he wanted to recreate the same opposition, the same tension that exists in Torcello's Church, *The Last Judgement* at the door and *The Inviting* and *Glorious Apse* … We are cluttered with images and only abstract art can bring us on the threshold of the divine. It took courage for Rothko to paint nocturnal murals. But I feel that it was his greatness. Painters become great only through obstinacy and courage. Think of Rembrandt, think of Goya. Think of Cézanne…these paintings too are probably the most beautiful of Rothko."

The dark paintings on the walls seemed to mirror the melancholy and loneliness which Rothko apparently felt in the last years of his life. It was as if he had retired from life of his own free will. The art historian Barbara Rose compared the new chapel with the *Sistine Chapel* itself, and the famed *Matisse Chapel* in southern France. In each case, she wrote, "the paintings seem to glow mysteriously from within."

In the summer of 1966, the Rothkos went on their last visit to Europe, during which they visited Lisbon, Majorca, Rome, Spoleto, and Assisi. From Italy, they traveled north to France, Holland, Belgium, and England. The last stop on their tour was to the Tate Gallery in London. For several months, Rothko had been in negotiations with the Tate director, Sir Norman Reid. Reid had visited Rothko in New York and suggested the notion of a permanent "Rothko Room" at the Tate. Rothko declined the idea of exhibiting a "representative" group of his works. Instead, he proposed to give Sir Norman a selection of the Seagram Murals. The

PAGES 76/77:
*Mural, Section 3 (Black on Maroon)*
*[Seagram Mural],* 1959
Oil on canvas, 266.7 x 457.2 cm
London, The Tate Gallery, presented by the
artist through the American Federations of Arts

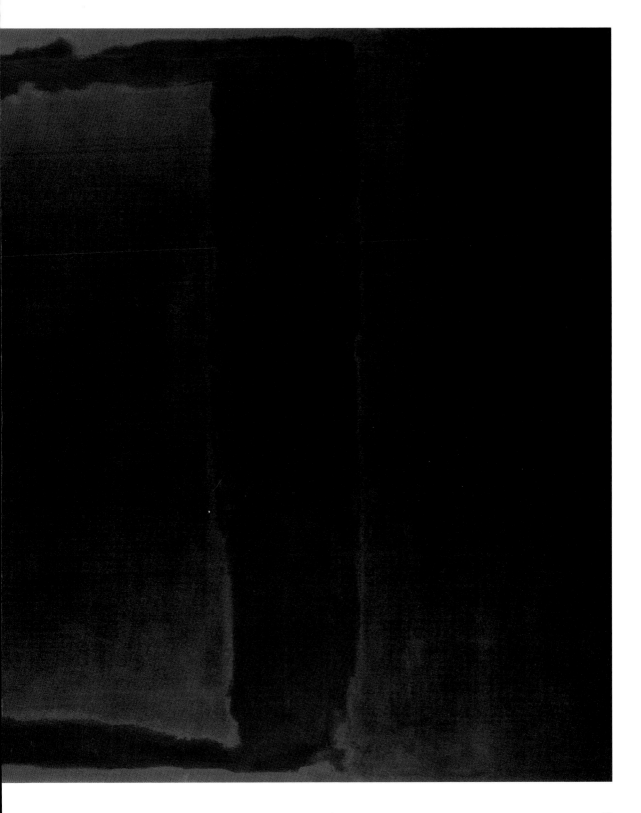

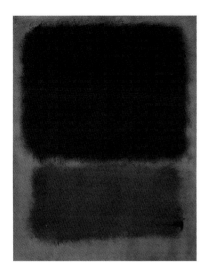

**Untitled**, 1968
Oil on paper, mounted on canvas, 61 x 45.7 cm
Aaron I. Fleischman

deliberations stretched over a period of several years, owing to a series of misunderstandings and to Rothko's indecisiveness. Nevertheless, the size of the room and its lighting both appealed to the artist. Back in New York, Rothko wrote to Reid in August, 1966: "It seems to me that the heart of the matter, at least for the present, is how to give this space you propose the greatest eloquence and poignancy of which my pictures are capable. It would help a great deal if there exists a plan which you could send me. I could then think in terms of a real situation and it would make something concrete, at least for me." Rothko made it clear to Reid that he would like to have his paintings hung in the older section of the museum, next to the works of Turner. Said Rothko, "I still hold the room at The Tate as part of my dreams." Following long deliberations, nine of the *Seagram Murals* were eventually brought to London shortly after the artist's death, to be permanently exhibited in a separate room.

Rothko's wish to have the *Seagram Murals* shown together in one room reflected his thoughts on how to ideally present his works. He wanted to create a kind of "domicile" for these paintings, into which a visitor entered physically. Following his earlier words, observers should find a dialog with his paintings, as "a consummated experience between picture and onlooker." Rothko sought to have his visitor enter a universe of stillness, to set him into an atmosphere of meditative contemplation and awe.

In the spring of 1968 Rothko was hospitalized with an aneurysm of the aorta, the result of his high blood pressure. He was encouraged to eat a more balanced diet and, especially, to reduce his alcohol intake and stop smoking. In addition, his doctor forbade him from working on pictures larger than one yard in height. His marriage, already strained and now openly fractured by the impotence he suffered owing to his illness, became a further burden. Although his declining health frightened him, Rothko continued to drink and smoke. The family spent the summer of 1968 in Provincetown. Because of his health, Rothko had begun to work in smaller formats, using acrylics on paper. These quickly finished works reflected his classic rectangular color formations. Katharine Kuh's later assessment was unsparing: "He had worked on the Houston chapel with such devotion that afterward he was practically burned out."

The holiday together did little to alleviate Mark and Mell Rothko's marital problems. They separated on January 1, 1969. Rothko moved into his studio. His increasing wealth did nothing to reduce his parsimony. His friends became concerned that his health was worsening, that he was becoming increasingly suspicious, anxious, and lonely. He was depressive, suffered from symptoms of confusion, and was sometimes intoxicated by heavy drinking, smoking, and excessive consumption of medications. He met often for a time with Rita Reinhardt, the attractive German-born widow of the artist Ad Reinhardt, but still could not find a way to recover from the separation with Mell.

Mark Rothko's acceptance and fame continued to grow following each exhibition, even as he felt himself isolated and disparaged. For example, an exhibition of his work at London's Whitechapel Gallery was enthusiastically received by the press and the public alike. Critic Bryan Robertson marveled at the entire body of work and its emotional power, stating, "We are left with a presence rather than a specific identity." In *New Statesman* of October 20, 1968, David Sylvester wrote of "the complete fulfillment of Van Gogh's using color to convey man's passion," a sentiment echoed by Alan Bowness in *The Observer*. Critic and painter Andrew Forge wrote, "When I first saw Rothko's work I felt I had fallen into a dream."

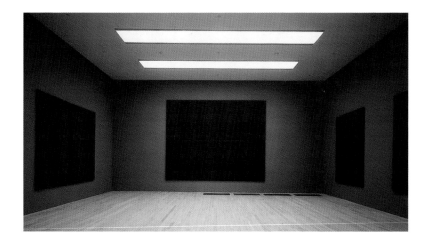

The Mark Rothko Room,
London, Tate Gallery

Rothko was voted a member of the National Institute of Arts and Letters in May 1968. A year later he received the honorary doctorate from Yale. The award read in part: "As one of the few artists who can be counted among the founders of a new school of American painting, you have made an enduring place for yourself in the art of this century… your paintings are marked by a simplicity of form and a magnificence of color. In them you have attained a visual and a spiritual grandeur whose foundation is the tragic vein in all human existence. In admiration of your influence which has nourished young artists throughout the world, Yale confers upon you the Degree of Doctor of Fine Arts."

Meanwhile, the artist had reached a point where he could afford to reduce the number of paintings he sold, choosing only to deal with selected patrons for whom he had an actual liking. To this end, he would conduct an "interview" before selling a piece. He confided to a friend that he no longer needed a gallery. He could easily sell what he wanted from his studio, which would be enough for him to live on. After his contract with Marlborough ran out in 1968, he decided not to renew immediately, obviously unhappy with Lloyd's business practices. He did, however, sign a second contract with the Marlborough Gallery in February 1969, naming them as his sole representative for the next eight years. This change of heart can be traced to Bernard Reis. Much more than just a counsel in financial matters, Reis had become one of Rothko's most personal confidants, and mixed himself up in all of the artist's concerns. Rothko, ill and unsure of himself, became increasingly dependent on Reis. Reis also advised Rothko on creating a foundation. For some time, Rothko had wanted to start such a project. In June 1969, the Mark Rothko Foundation was finally begun with William Rubin, Robert Goldwater, Morton Levine, Theodoros Stamos and Reis as members. Producer Clinton Wilder, a client of Reis, was named as president. The foundation was promised a large number of the artist's important works following his death, and was also intended – as obscurely worded in the foundation's statutes – to serve the interests of "research and education." From Rothko's point of view, the foundation was an attempt to find a safe repository for his paintings after death, in order to keep them away from the art market. Yet at the same time he continued to follow Reis's advice and sold pictures to the Marlborough Gallery. In February 1970, a representative of the Marlborough Gallery, Donald McKinney, arranged a visit to Rothko's storeroom together with the artist, in order to select paintings for the gallery. Planned for February 25, the meeting was never to occur.

PAGE 80:
*Untitled,* 1968
Oil on paper, mounted on linen, 99,1 x 63.5 cm
Private collection

PAGE 81:
*Untitled,* 1968
Oil on paper, mounted on linen, 99 x 65.1 cm
Courtesy Waddington Galleries, London

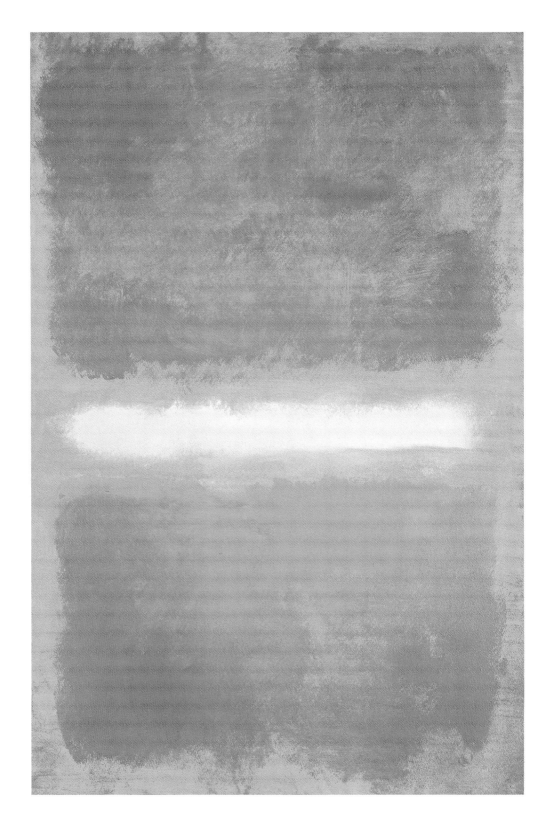

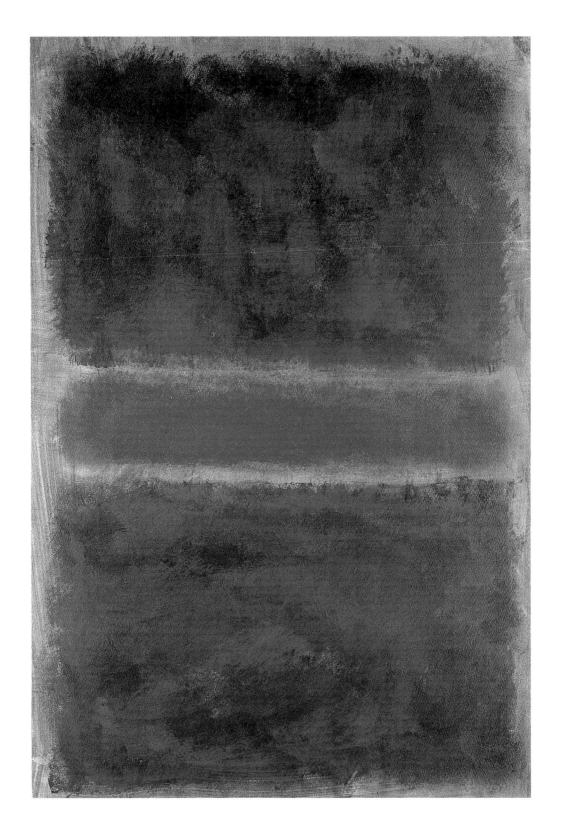

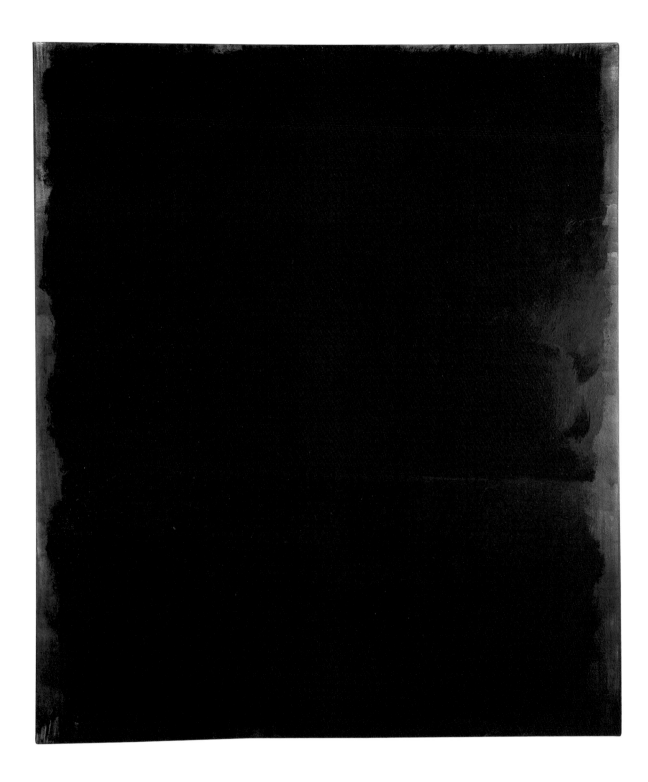

# Rothko's Death and Legacy

On that cold Wednesday morning, Rothko's assistant Oliver Steindecker came to work as usual at nine o'clock. He unlocked the door to the studio on 69th Street on Manhattan's Upper East Side and called out a robust "good morning," as he did every day. But on this morning there was no answer. Steindecker went to Rothko's bed, which he discovered to be empty. He searched everywhere, finally going to the section where the kitchen and bath were located, to find Rothko lying on the floor beside the sink, covered in blood, with both of his arms slit open and a razor blade by his side. Steindecker called the police, who arrived minutes later. The emergency doctor was able only to establish Rothko's death, later diagnosed as a suicide. The autopsy showed that aside from the deep incisions, the artist had also suffered an acute poisoning from anti-depressants. Mark Rothko was 66 years old.

The next morning, all of the New York dailies from the trashy *Post* to the venerable *Times* ran front-page stories on the tragic suicide by "the pioneer of Abstract Expressionism, regarded as one of the greatest artists of his generation." For some of Rothko's closest friends, the suicide was not a complete surprise. He had seemed to have lost his inspiration and passion. His last works, painted with matte acrylics on paper and canvas, appeared rigid, dark and hermetic, and seemed to some robbed of any emotive power which might enable a viewer to open a lively dialog. These paintings appeared to reflect Rothko's innermost self: despondent, depressive, frustrated, melancholic, lonely.

His friends recalled the suicide of the artist Arshile Gorky in 1948, and the tragic deaths of Jackson Pollock and David Smith in car accidents. Some of Rothko's closest friends came to view his suicide as a kind of ritual victimization. Rothko did not leave a note to explain his actions. There were rumors of intrigue, though these were little researched. Rothko's daughter, Kate, was 19 at the time of her father's death; her brother Christopher was just six. On February 28, fellow artists, collectors, art dealers, museum directors, curators and old friends gathered to fill the Frank E. Campbell funeral parlor. Rothko's brothers Albert and Moise flew in from California to pay their respects. The poet Stanley Kunitz delivered the eulogy. Rothko, he said, was "one of the fathers of Twentieth-Century American painting, whose posterity is already visible on the walls of every museum of contemporary art. Others could and still do produce paintings that resemble his, but Mark's transcendental quality, his effect of a pulsing spiritual life, of an imminent epiphany, was a secret he did not share with others, and

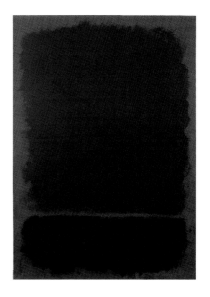

*Untitled*, 1969
Acrylic on paper mounted
on canvas, 147 x 103 cm
Private collection

*Untitled*, 1969
Acrylic on paper, mounted on board,
122 x 103 cm
Private collection

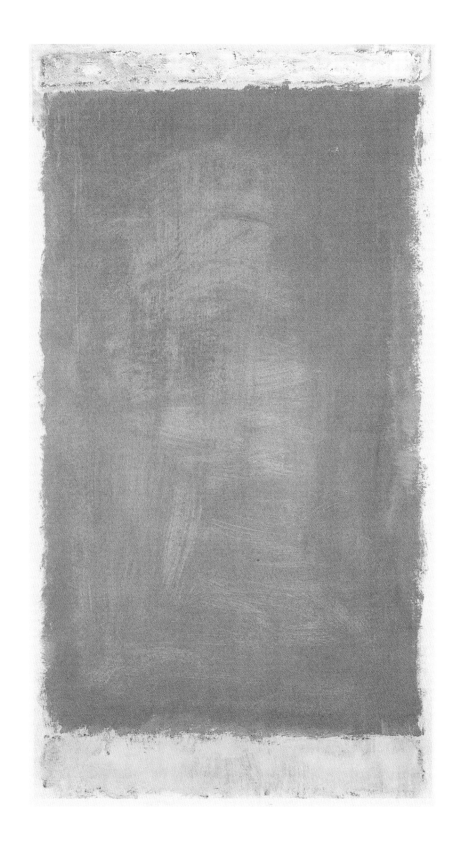

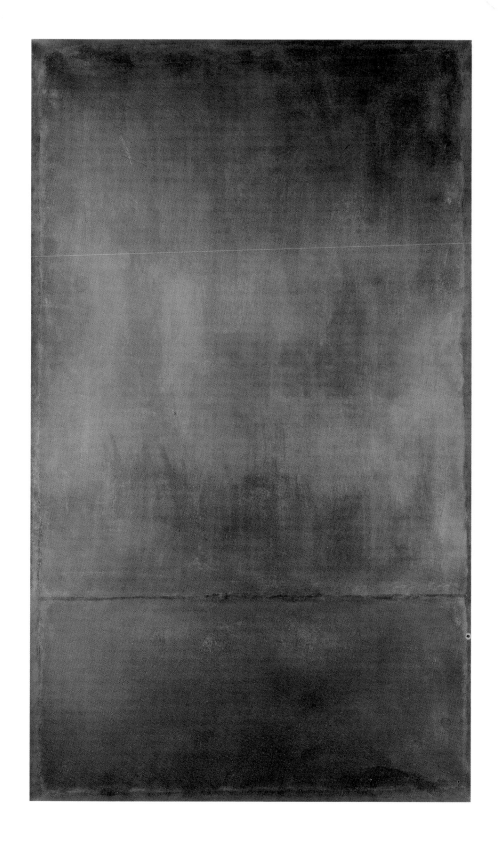

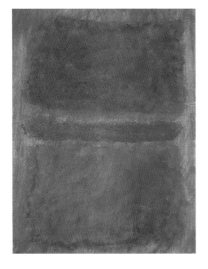

*Green Divided by Blue*, 1968
Acrylic on paper mounted on canvas,
60.6 x 45.1 cm

maybe only partly understood himself… So much of Rothko remains – in a multiplicity of glowing presences, in a glory of transformations. Not all the world's corruption washes high colors away."

The sculptor Herbert Ferber spoke about their many years of friendship. At the end of the ceremony, Rothko's brother recited from the Kaddish, the Jewish Prayer of the Dead. Many people who attended the funeral remained afterwards on the Madison Avenue sidewalk to talk about Rothko's exceptional career and to express their regrets.

A mere half-year later, on August 26, 1970, Mell Rothko died at the age of 48. Her death was a shock for both her children and her friends. Christopher, Rothko's youngest son, was adopted by Dr. Levine, one of the managers of his estate. Kate soon became unhappy about the strict treatment the young boy was receiving in Levine's care, and collected him in short time to bring him to her aunt, Mell's sister Barbara Northrup, who lived in Columbus, Ohio.

In his testament, Rothko had named the anthropologist Dr. Morton Levine, the artist Theodoros Stamos and Bernard J. Reis as managers of his estate. At the insistence of Reis, the three came together a few months after the burial in order to examine and comb through the nearly 800 works in their charge. Reis, who portrayed himself as a "friend" of Rothko's, in fact proved two-faced and deceitful. While advising Rothko during his increasingly difficult final years, Reis had remained entirely silent to the fact that he was acting for the Marlborough Gallery as a tax adviser, accountant and agent. Reis and the other executors then sold a large body of his works to Marlborough for a fraction of their actual worth. These were purchased though mere down payments, with the remainder to be paid over a period of 14 years, interest-free.

Catching wind of the swindle, Rothko's daughter Kate decided in November 1970 to take both the estate managers and Marlborough to court. The case took several years to resolve, becoming one of the greatest scandals of the art world. Until that time, there had never been a trial of such huge proportions involving fraudulent dealings with art. On December 18, 1975, Judge M. Middonick finally read his decision. The three executors of Rothko's estate were ordered to forfeit their posts, the contract with Marlborough was ruled invalid. The judge enjoined the return of 658 unsold paintings to Rothko's estate. Compensatory damages were set at more than nine million dollars.

The court named Kate Rothko-Prizel as the sole administrator of Rothko's estate. She decided on the Pace Gallery in New York, directed by Arne Glimcher, as the exclusive representative of her father's work. The first Rothko exhibition at the Pace Gallery coincided with a Retrospective of over 100 works at the Guggenheim Museum in New York in 1978. In May 1976, seven directors were chosen for a new Rothko foundation. These included Dorothy C. Miller, a curator at the Museum of Modern Art, and Thomas Messer, the director of the Guggenheim Museum. In the meantime, the Rothko Foundation had donated more than 600 paintings to 25 museums in the United States, as well as to four in Europe and two in Israel. The foundation also supported impecunious artists, following Rothko's original wishes.

Mark Rothko today has his place as one of the most important painters of post-World War II modernism. His radical refusal to copy nature reduced painting to large, vibrant fields of color. His works were a seminal influence on the development of monochrome painting. Remarkable is their spatial depth and meditative power, which engage the viewer in a dialog with the work. "One was forced to enter fully into the work… to wander around its interiors," wrote

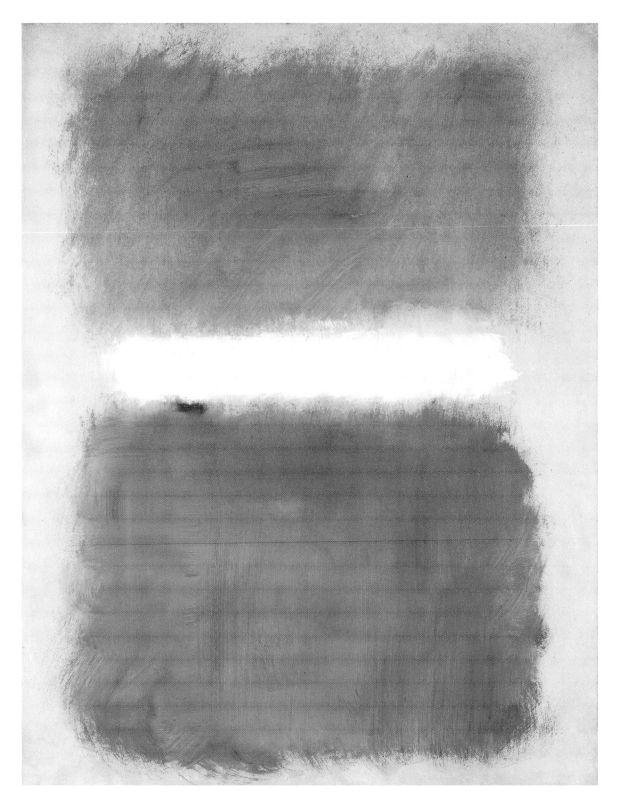

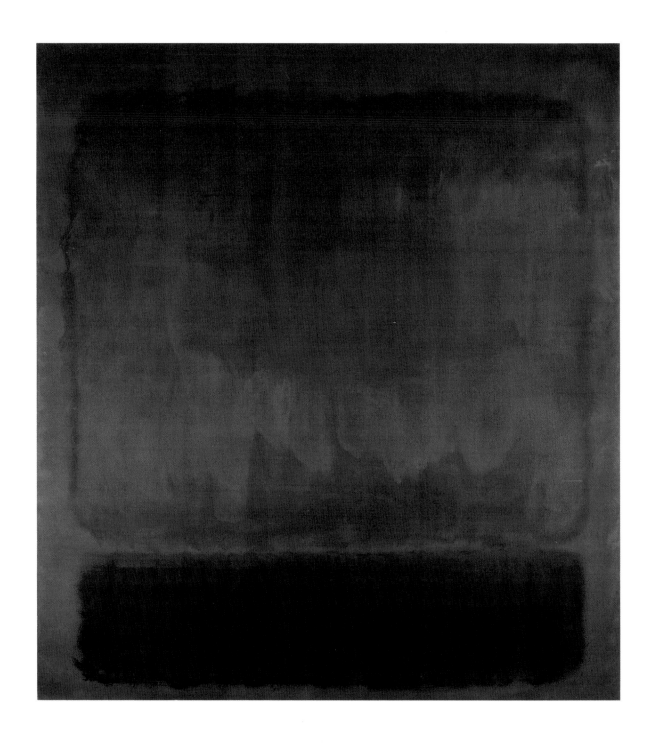

ABOVE:
*Untitled*, 1967
Oil on canvas, 173 x 153 cm
Private collection

RIGHT:
*Untitled*, 1969
Acrylic on paper mounted on canvas,
193 x 122 cm

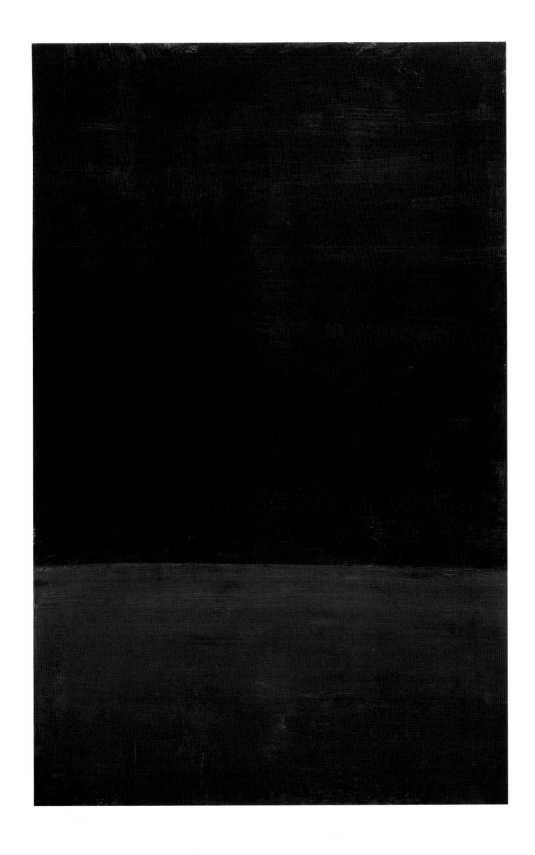

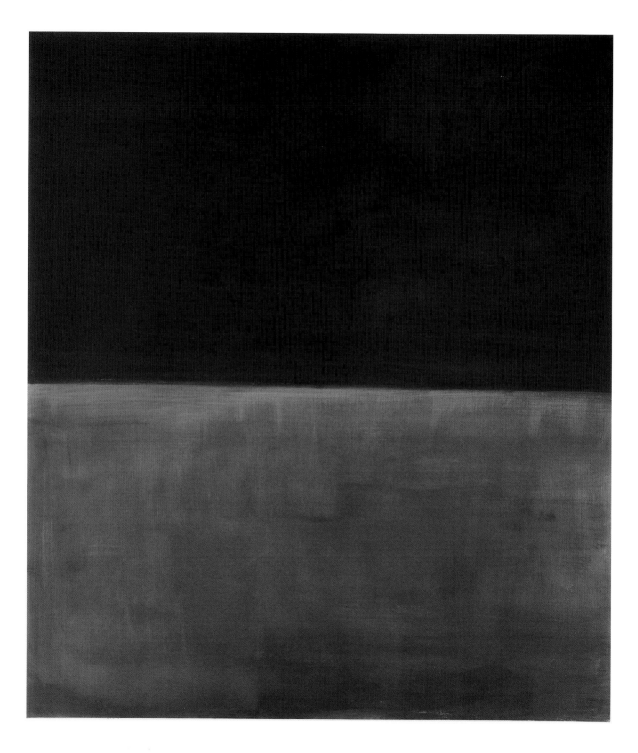

*Untitled (Black on Gray),* 1969/70
Acrylic on canvas, 203.8 x 175.6 cm
New York, Solomon R. Guggenheim Museum,
gift of The Mark Rothko Foundation, Inc., 1986

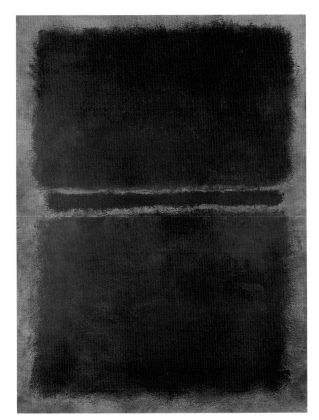
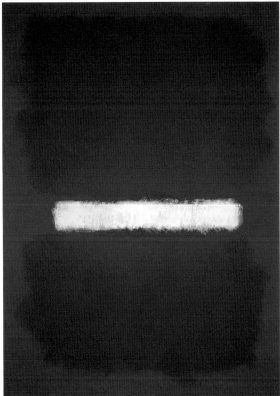

collector Ben Heller, who said that his encounter with Rothko's painting was the "most direct picture experience" that he ever felt. In his memoirs, Heller describes with passion the essence of Rothko's paintings: "How could he, with such a small number of variations, initiate discussions between picture and viewer as personal, direct and intimate as chamber music? How could he, with these few combinations in a palette of hot and cold, bright and dark, shiny and matte, rapturous and melancholy colors, call forth feelings that recreate the breadth, variety, drama, depth and panorama of the orchestral music he so utterly loved? Who can answer such questions? Only the pictures themselves – and each observer."

Rothko told Katherine Kuh that if he had to put his trust in something, he would put it in the psyche of the sensitive viewer who is free of conventional patterns of thought. Rothko said that he knew nothing of how the viewer would use his pictures to meet the needs of his spirit, but that when the viewer had both needs and a spirit there could be a true exchange.
ROTHKO in a letter to Katherine Kuh, 1954

# Mark Rothko 1903–1970
## Chronology

**1903** Marcus Rothkowitz born to Anna Goldin and Jacob Rothkowitz as the youngest of four children on Sept. 25 in Dvinsk, Russia.

**1910** Father Rothkowitz emigrates to the United States and settles in Portland, Oregon.

**1913** Marcus, his mother and sister emigrate to the United States. The family is reunited.

**1914** The father dies.

**1921–23** Marcus attends Yale University in New Haven, Connecticut.

**1924** Takes anatomy with George Bridgeman at the Art Students League (ASL) in New York City.

**1925** Studies painting with Max Weber at ASL. Paints on canvas and paper in the Expressionist style, under Weber's influence. Always makes sketches in advance of painting.

**1926** Continues studies under Weber.

**1929** Starts teaching children at the Jewish Center Academy in Brooklyn.

**1932** Meets and befriends Milton Avery and Adolph Gottlieb. Marries Edith Sachar.

**1933** First one-man show, at the Portland Museum of Art in Oregon. Shows drawings and aquarelles at the Center Academy, along with works by his students.

**1935** Co-founder of the independent artists' group The Ten. Members include Ben Zion, Adolph Gottlieb,

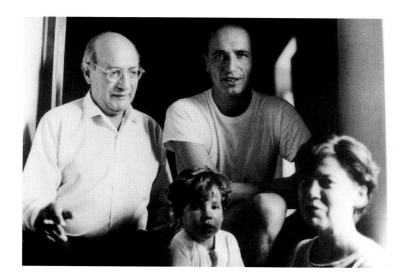

*Mark Rothko with the Italian painter Carlo Battaglia in Rome,* 1966
On the right: Mell Rothko and son Christopher
Courtesy Carla Panicali, Rome

PAGE 93 ABOVE:
*Mark Rothko in his studio,* c. 1950
Courtesy Archives of American Art,
Smithsonian Institute, Washington, DC

PAGE 93 BOTTOM LEFT:
*Mark Rothko in his studio,* 1953
Courtesy Archives of American Art,
Smithsonian Institute, Washington, DC;
Photo: Henry Elkan

PAGE 93 BOTTOM RIGHT:
*Mark Rothko,* 1966
Courtesy Carla Panicali, Rome;
Photo: Robert E. Mates

Louis Harris, Jack Kufeld, Louis Schanker, Joseph Solmon, Nahum Tschacbasov and Ilya Bolotowsky. Rothko shows only with The Ten until the group is dissolved in 1940.

**1936** Works at the painting department of the WPA in New York.

**1938** Becomes a citizen of the United States.

**1940** Henceforth uses only the name Mark Rothko.

**1941** Paints works drawn from mythology on canvas and paper.

**1944** Works in an abstract, surrealist style. Numerous works on paper with aquarelle, gouache and tempera. Divorces Edith Sachar.

**1945** Marries Mary Alice ("Mell") Beistle.

**1946** Paints the last of his surrealist works, on paper.

**1947** Paintings become increasingly abstract, with the rise of the multiforms, which within a few months evolve into the rectangular color formations characteristic of the late peri-

od. In this transition phase he paints less works on paper. First one-man show at the Betty Parsons Gallery in New York.

**1948** Takes part in the Annual Exhibition for Contemporary American Sculpture, Watercolors and Drawings at the Whitney Museum of American Art in New York. Mother Kate dies in the fall.

**1949** Teaches painting and holds lectures on contemporary art at the

California School of Fine Arts. First show of mature pictures at Betty Parsons Gallery. Henceforth "titles" his paintings only with numbers and years.

**1950** Ocean liner trip to Europe, visiting England, France and Italy. Daughter Kate is born.

**1951** Becomes professor of drawing at Brooklyn College.

**1952** Participates in the famous "15 Americans" show at the New York Museum of Modern Art.

**1954** Exhibits at the Art Institute of Chicago. The exhibition later travels to the Rhode Island School of Design in Providence, Rhode Island. Contract with the Sidney Janis Gallery in New York.

**1955** One-man show at the Sidney Janis Gallery.

**1957** Becomes artist-in-residence at Tulane University in New Orleans. Reduces his palette vs the darker hues.

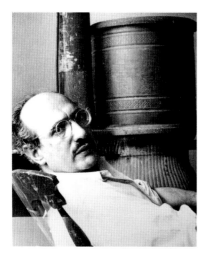

**1958** Receives contract to paint murals for the Seagram's Building in New York.

**1959** Journey to Europe with visits to England, France, Belgium, the Netherlands and Italy. After a visit to the space that he is supposed to decorate on behalf of Seagram's, decides to pull out of the contract.

**1961** Hired by Harvard University to decorate a dining hall at the Holyoke Center with murals.

**1963** Sends six murals to Harvard. The university asks him to choose five for a permanent installation. Birth of his son, Christopher. Contract with the Marlborough Gallery in New York.

**1964** Hired by John and Dominique de Menil to create monumental murals for a new chapel in Houston.

**1965** Enters talks with Sir Norman Reid, director of the Tate Gallery, on donations to the Museum. Nine of the *Seagram Murals* are installed permanently in a room at the Tate in 1970.

**1966** Third and final journey to Europe.

**1967** Teaches at the University of California in Berkeley.

**1968** Suffers an aortal aneurysm; three weeks in hospital. Begins to catalog his work.

**1969** Separation from Mell. Moves out of their house and into his studio. Begins to work on the "Dark Paintings." Receives an honorary doctorate from Yale.

**1970** Rothko commits suicide on February 25.

**1971** Dedication of the *Rothko Chapel* in Houston, Texas. The building belongs to the Rice University Institute for Religion und Human Development.

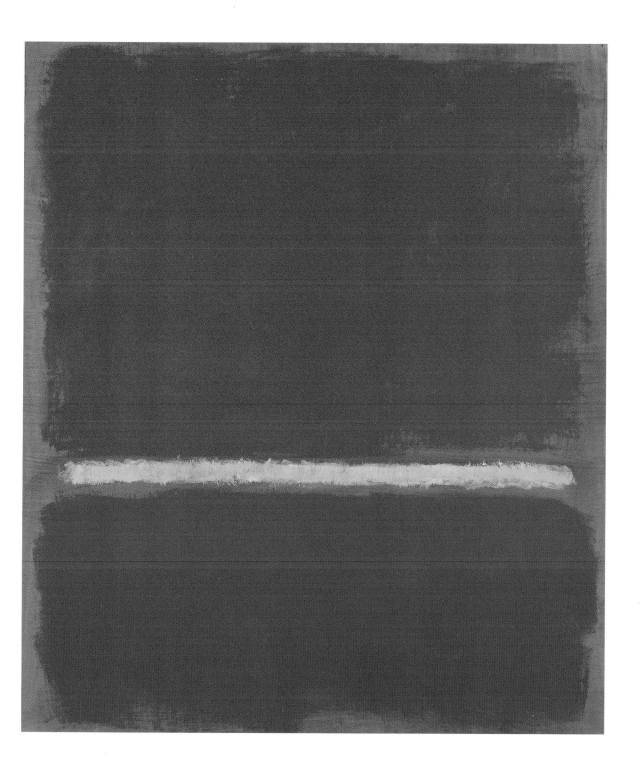

***Red, Yellow, Red***, 1969
Oil on paper mounted on canvas, 123.2 x 102.9 cm
Private collection

# Selected Bibliography

# Picture credits

James Breslin, *Mark Rothko: A Biography,* Chicago, 1993.

Peter Selz, *Mark Rothko,* (Exh.-cat.) The Museum of Modern Art, New York, 1961.

*Mark Rothko: The 1958–1959 Murals,* (Exh.-cat.) Pace Gallery, New York, 1978.

Diane Waldman, *Mark Rothko, 1903–1970. A Retrospective,* (Exh.-cat.) The Solomon R. Guggenheim Museum, New York, 1978.

*Mark Rothko: The Surrealist Years,* (Exh.-cat.) Pace Gallery, New York, 1981.

Dore Ashton, *About Rothko,* New York, 1983.

*Mark Rothko: Paintings 1948–1969,* (Exh.-cat.) Pace Gallery New York, 1983.

Bonnie Clearwater, *Mark Rothko: Works on Paper,* New York, 1984.

*Mark Rothko: The Dark Paintings 1969–1970,* (Exh.-cat.) Pace Gallery, New York, 1985.

*Mark Rothko: 1903–1970,* (Exh.-cat.) Tate Gallery, London, 1987.

*Mark Rothko: The Seagram Mural Project,* (Exh.-cat.) Tate Gallery, Liverpool, 1988.

*Mark Rothko's Harvard Murals,*(Exh.-cat.) Center for Conservation and Technical Studies, Harvard University Art Museum, Cambridge MA, 1988.

Susan J. Barnes, *The Rothko Chapel: An Act of Faith,* Austin, Texas 1989.

Anna C. Chave, *Mark Rothko: Subjects in Abstraction,* New Haven and London, 1989.

Thomas Kellein, *Mark Rothko: Kaaba in New York,* (Exh.-cat.) Kunsthalle Basel, 1989.

*Mark Rothko: Multiforms,* (Exh.-cat.) Pace Gallery, New York, 1990.

Christoph Grunenberg, *Mark Rothko,* (Exh.-cat.) National Gallery of Art, Washington DC, 1991.

Lee Seldes, *The Legacy of Mark Rothko,* New York 1978 (Holt, Rinehart and Winston, 1978; new edition Da Capo Press, 1996).

*Mark Rothko: Catalogue Raisonné of the Paintings,* 1997, ed. Yale University Press and The National Gallery of Art, Washington DC.

*Mark Rothko. A Retrospective,* (Exh.-cat.) The National Gallery of Art, Washington DC, 1998.

*Mark Rothko: The Early Years,* (Exh.-cat.) Pace Gallery, New York, 2001.

*Mark Rothko,* (Exh.-cat.), Fondation Beyeler, Riehen, Basel, 2001.

The publisher wish to thank the museums, private collections, archives and photographers who granted permission to reproduce works and gave support in the making of the book. Special thanks to Christopher Rothko for his good cooperation. If not otherwise specified, the reproductions originated from the archives of the publisher or the author. In addition to the collections and museums named in the picture captions, we wish to credit the following:

Acquavella Galleries, New York: p. 52; Courtesy Archives of American Art, Smithsonian Institute, Washington, DC: Back cover, p. 93 above, 93 below left (Photo: Henry Elkan), 94 below; C & M Arts, New York: p. 8, 12, 13, 33, 57 above, 68, 80, 87, 95; © 2003 Christie's Images Ltd., London/New York: Front cover, S. 36, 41 right, 56, 82; © The Chrysler Museum of Art, Norfolk, VA: p. 49 below; Collection of Kawamura Memorial Museum of Art, Chiba-Ken, Japan: p. 60–65; Gagosian Gallery, New York: p. 15, 31, 45, 47, 70; Galerie Beyeler, Basel: p. 91 left; Marge Goldwater, New York: p. 44; James Goodman Gallery, New York: p. 73, 83, 89; Richard Gray Gallery, Chicago/New York: p. 91 right; Sidney Janis Gallery, New York: p. 50; Knoedler Gallery, New York: p. 6; The Menil Collection, Houston, TX, Photo: Hickey-Robertson: p. 14, 34; National Gallery of Art, Washington: p. 22 (Photo: Richard Carafelli), 27, 30, 32, 34; Courtesy Carla Panicali, Rom: p. 92, 93 below right (Photo: Robert E. Mates), 94 above right, 94 above left; The Phillips Collection, Washington, DC, p. 67; © President and Fellows of Harvard College, Harvard University Art Museums, Photo: Katya Kallsen: p. 69; Quesada/Burke, New York: p. 19, 35; The Mark Rothko Foundation, Inc., New York: p. 17, 18, 25, 41 left, 59; © The Solomon R. Guggenheim Foundation, New York: p. 11 (Photo: David Held), 90; © Tate Gallery, London: p. 76/77, 79; Tel Aviv Museum of Art, Tel Aviv: p. 48; University of California, Berkeley Art Museum, Photo: Benjamin Blackwell: p. 71; Waddington Galleries, London: p. 81.